HIGH IMPACT
PORTRAIT PHOTOGRAPHY

CREATIVE TECHNIQUES FOR DRAMATIC, FASHION-INSPIRED PORTRAITS

Lori Brystan

AMHERST MEDIA, INC. ■ BUFFALO, NY

dedication

First of all, thank you to my wonderful assistant, Ron Goodger, who helped me with all of the shots in this book. Thank you to my family and friends, to all the special people in this book, and to my team of employees. It was truly a group effort to make this book happen.

And to my daughter, Skyler, a special thank you for showing me love and the beauty of the soul.

Published by:
Amherst Media, Inc.
P.O. Box 586
Buffalo, N.Y. 14226
Fax: 716-874-4508
www.AmherstMedia.com

Publisher: Craig Alesse
Senior Editor/Production Manager: Michelle Perkins
Assistant Editor: Barbara A. Lynch-Johnt

ISBN: 1-58428-062-X
Library of Congress Card Catalog Number: 2001 132050

Printed in Korea.
10 9 8 7 6 5 4 3 2 1

778.92
Brys

Notice of Disclaimer: The information contained in this book is based on the author's experience and opinions. The author and publisher will not be held liable for the use or misuse of the information in this book.

table of contents

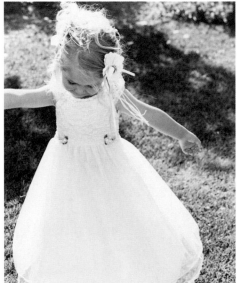

Section 2: Men

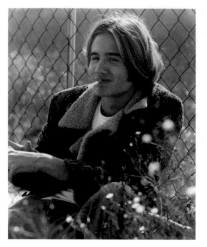

Section 3: Women

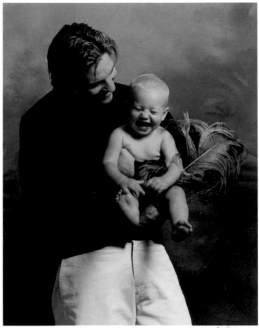

about the author

Although she now works behind it, Lori Brystan began her career in front of the camera. Entering the modeling business when she was was sixteen years old, she signed with Elite, one of the best agencies in Los Angeles, and brought her all-American girl image to magazines and catalogs for the next two to three years.

While working as a model, Lori's contact with the hair and makeup artists on the shoots sparked an interest in cosmetology. "I always hung out with the makeup artists on the set," she says, "because I thought their jobs seemed a lot more interesting than modeling." After graduating high school, she consequently enrolled in cosmetology school and earned her license in that field.

Getting started by drawing on personal connections made during her modeling career, Lori built a successful career as a professional makeup artist and hairstylist for print and video. Before long, however, she found herself being hired not only to do makeup and hair, but for her creative ideas. With her artistic sensibilities and eye for unusual angles, Lori's creative input became a valued asset to her clients—although she freely

. . . their jobs seemed a lot more interesting than modeling.

admits she didn't yet know the technical aspects of the photography business at all.

After seven years, Lori decided she was sick of freelancing and wanted to exert more control over her income and professional life. She decided to start her own business.

Looking around her area in the late 1980s, Lori didn't see any portrait studios offering clients a magazine-style look—or even black & white portraits. "I thought," she says, "if I had a family, I'd want to do something cool—I wouldn't want run of the mill portraits with fake trees and stiff poses."

With this in mind, Lori opened a studio designed to give people high quality images with an updated, magazine-style look. When her first client bought $900 in black & white head shots, she knew she was on to something.

When Lori started the business, it was her intention that, being a good businessperson, she would run the business and do the makeup and hairstyling. She planned to get a partner who was a photographer to do the actual picture-taking.

"I had no intention of learning photography," Lori remembers, "It seemed too hard, too technical—taking notes, moving stuff." The series of events that followed , however, changed her mind about getting behind the camera.

Although she opened the studio with a photographer partner, as she had planned, Lori bought him out of his share of the business only six months later when it became clear that their goals for the business did not coincide. "All of a sudden", she says, "I found myself sitting there with a studio and a business to run—and I didn't even know how to take pictures!"

That was the moment I knew it wasn't going to work . . .

Making one last effort to work with an outside photographer, Lori hired a friend to do sessions. While this worked for a while, one day the photographer walked out of a session and told Lori he "couldn't do anything" with that client. "That was the moment I knew it wasn't going to work," Lori recalls. "I wanted to make people feel good about how they look. I realized that no one was going to put their heart and soul into it the way I would. I would have seen the beauty in her and worked with it."

It was a decisive moment. Lori promptly refinanced her home and bought $10,000 worth of photography equipment—equipment she didn't even know how to use. "My first camera was a Hasselblad," she notes, "and I didn't even know what an f-stop was."

Lori learned the basics from a friend. "He literally put tape on

the floor and said 'Put the light here and set it to f/11,'" she laughs. With the exception of a few weekend seminars, though, she learned photography by trial and error. "I puzzled everything out," she says, "I'd look at a shot, and if it didn't look good I'd try to figure out how I could fix it."

From her first shoot, things went well. "I wasn't technically educated," she says, "but I had a good eye. I'm more well-rounded now, but that's still my greatest strength."

In the years that followed her transition to a career behind the camera, Lori has continued to build her business and thrill clients with images that make them look better than they ever thought they could. "It sounds sappy," she says, "but I love what I do because I've seen it change people's lives. At least fifty percent of my clients come in saying, 'I hate having my picture taken, I never get a good picture.' It's exciting to really turn them around and make them feel good by giving them a great portrait."

If that wasn't enough incentive to enjoy her life behind the camera, Lori has another reason for her enduring passion for photography. "I love my career because I know I can always be better. I never feel like I know everything, so I'm always motivated to learn—and I never get bored!"

For more information on Lori or her studio, visit her on-line at: www.brystan-studios.com.

I love what I do because I've seen it change people's lives.

HAVING A PLAN

concept

I generally don't approach a shoot with one concrete idea about the image I want to produce. Instead, I make sure the hair and clothes look good and let the rest grow naturally from there.

Especially with kids, if you have a set plan, it will rarely work out the way you wanted. With active children, like this two year old, you can pretty much expect them to do what-

ever they want to do. Your best bet is to follow them around and keep your eyes open while they do it.

Some coaching can, of course, help to direct the process. Here, the boy was wearing red overalls and I saw this red rose in

Some coaching can, of course, help to direct the process.

the garden and asked him to hold it. Because I love reds and greens together, I worked him into an area where I could get this ivy wall in the background.

lighting

This image was shot outdoors in direct, late afternoon sun. Because of the time of day, the sun provided light from a low angle. The boy was photographed while turned toward the sun for even lighting on his face and body. The peachy color of the late day light make his skin glow with warmth.

lens selection

The 150mm lens is probably my favorite. Here, it lets the background recede out of focus and keeps the little boy the center of attention. If I wanted to show a little more of the background, I would select a 110mm lens instead.

exposure

I overexpose most portraits by one or two stops. This cleans up the skin and makes it look much better than a straight exposure. Portraits with the skin "correctly" exposed, tend to look dark and muddy—not the clean, updated appearance I'm looking for in my images.

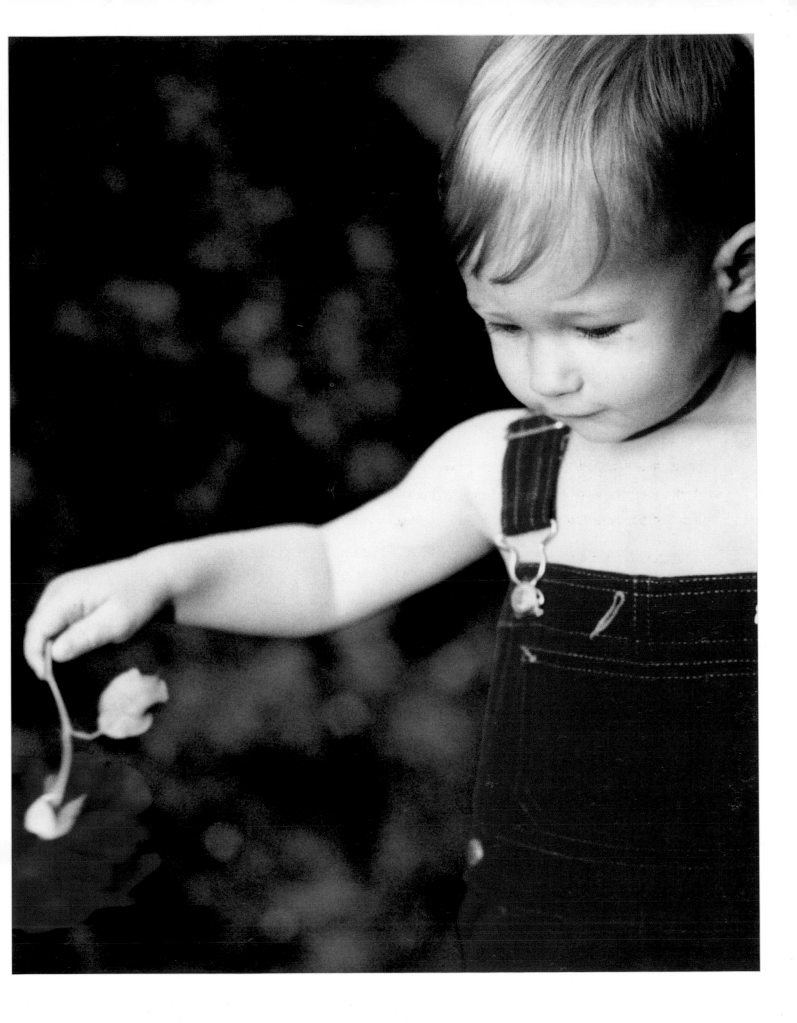

RED-ON-RED

creative control

Most of my clients are happy to give me a lot a of creative control over the concept and style of their portraits. I do, however, work to gauge clients' expectations and the style of image that is most likely to make them happy. I ask parents, for example, if they prefer images with their kids smiling into the camera or more candid, natural images. In the end, I generally end up shooting a mix of both types.

quick reference

CAMERA
Mamiya 645

LENS
150mm

FILTER
81B

FILM
Kodak VC 160

METERED AT
$1/_{60}$ second, f/11

EXPOSED AT
$1/_{60}$ second, f/8

OVEREXPOSED BY
one stop

LIGHTING
window light

concept

During the consultation, the parents told me that their son looked really good in red and had a cute pair of red overalls. As a result, we decided to do a

The parents told me that their son looked really good in red . . .

red-on-red portrait, with red overalls, a red backdrop and a shiny red apple.

Even with an intense color like red, the monochrome effect lets the little boy stand out nicely. This isn't the right look for every shoot, but it has a lot of possibilities (green apples and a green backdrop, or lemons with a yellow backdrop, perhaps).

props

I think fruit is a great prop for kids because it's so natural. For this shoot, we had lots of apples and there are other wonderful images of the boy laying in heaps of them!

window light

If I had to pick only one kind of lighting, I'd shoot with window light all day long. As you will see, it's used for most of the portraits in this book. Here, you can see one of the nicest features of window light—the great sparkle in this little boy's eyes. I find that window light always makes my subject's eyes look bright and lively.

clothing

With younger kids, I think skin. They can get lost in too many clothes, so I put this little boy in his red overalls without a shirt.

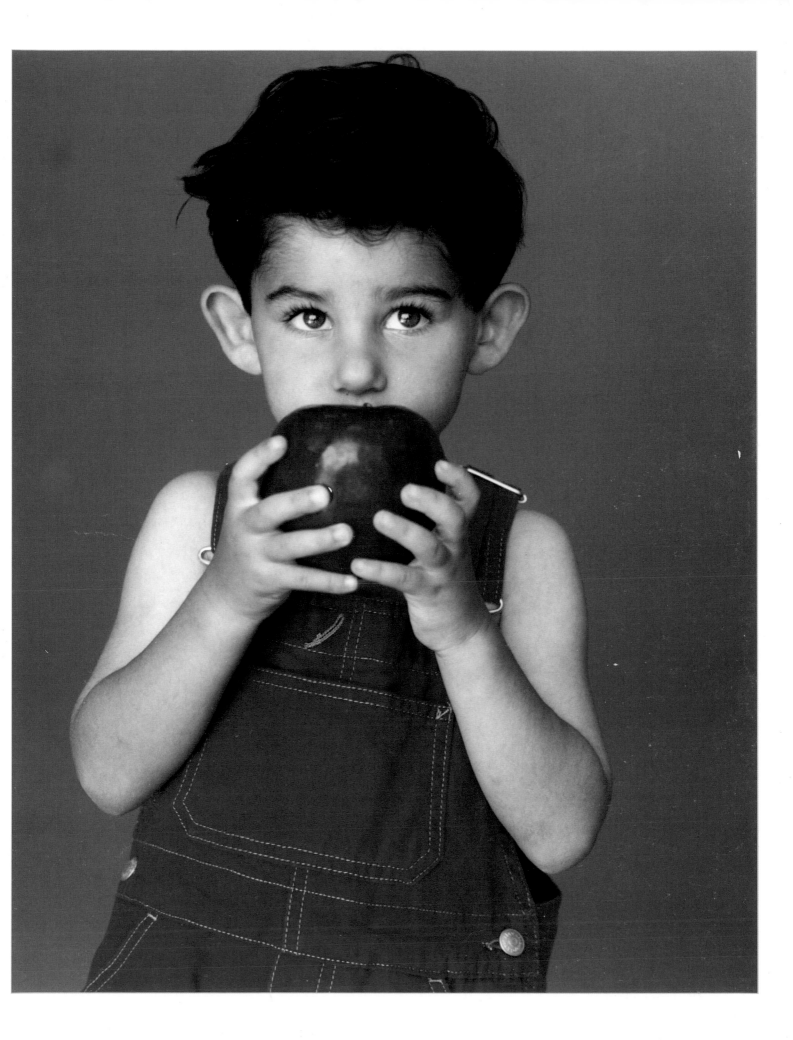

concept

At the session, I learned that the little girl had this nice summery yellow outfit. We decided to do a bright and sunny portrait using the yellow clothes paired with yellow flowers. This color scheme also complimented the girl's blond hair and blue eyes.

props

For shoots like this, I often ask my clients to bring flowers as props. In this case, they brought these vibrant yellow daisies to complete the color scheme.

lighting and set

The little girl was posed on a white 10' x 20' studio backdrop. She faced toward a large window—perfect for the light and sunny look we wanted to create.

time

When taking portraits of kids you need to work quickly. After about thirty minutes, they usually start to lose their enthusiasm and get bored or fussy.

This is another reason I prefer to use natural lighting—since you don't have to spend time checking or readjusting lights, you can spend your precious time getting great images. With natural light I get more images in less time.

posing

Once the girl was seated on the backdrop, I simply asked her to play with the flowers. I prompted her to put a flower here or there, and even asked her to put the flowers between her toes.

With natural light I get more images in less time.

The girl's expression is very natural. I never tell kids to smile or say cheese. I might tell them to say a silly word to try to get a smile, but that's about it. Ultimately, my clients (and I) prefer a natural expression over a fake smile.

filter

I like all of my portraits to look warm, so I use a warming filter (normally an 81B or 81C) on almost every image.

quick reference

CAMERA
Mamiya 645

LENS
150mm

FILTER
81B

FILM
Fuji NPH

METERED AT
$1/125$ second, f/8

EXPOSED AT
$1/125$ second, f/5.6

OVEREXPOSED BY
one stop

LIGHTING
window light

CHILDREN

16

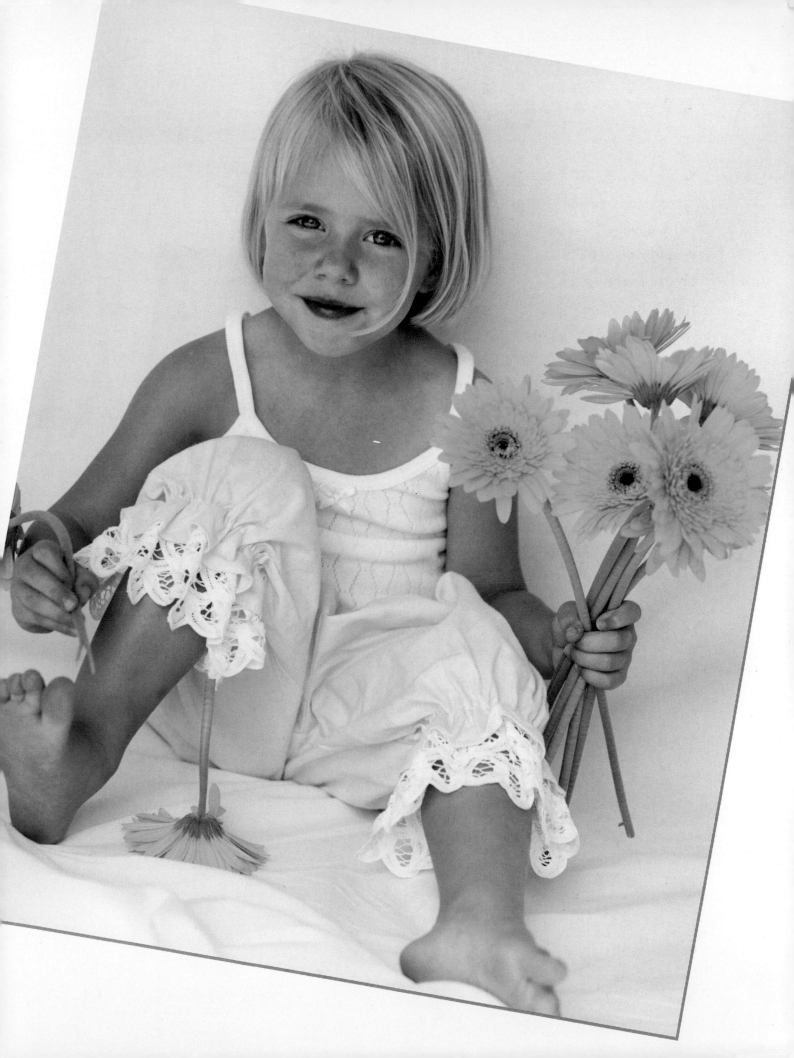

LAVENDER BABY

set

A white backdrop forms the base for this setup. On top of it, I placed a soft, white baby blanket that was bunched up a bit to make it look warm and snuggly. The baby is surrounded by flowers that the mother brought to the shoot on my request.

lighting

A large softbox was used as the main light for the

large softbox

quick reference

CAMERA
Mamiya 645

LENS
150mm

FILM
Kodak TMAX 100

METERED AT
$\frac{1}{60}$ second, f/8

EXPOSED AT
$\frac{1}{60}$ second, f/5.6

OVEREXPOSED BY
one stop

SPECIAL PRINTING
magenta tint

LIGHTING
large softbox high and
to the right (see diagram)

shot. It was placed high and to the right of the frame. Since everything around the baby was white, a lot of light bounced back from each side, creating a very soft look.

working with infants

When I work with very young children, I like to have mom nearby—usually just out of the frame. Sometimes little ones will stay put, other times they will crawl off and need to be placed back in position over and over. Having mom on hand makes this simpler, and also puts the baby at ease in a new environment.

expression

With little kids, be prepared to act like an idiot to get their attention and a good expression. I like to make funny noises or silly movements—blowing bubbles sometimes works, too.

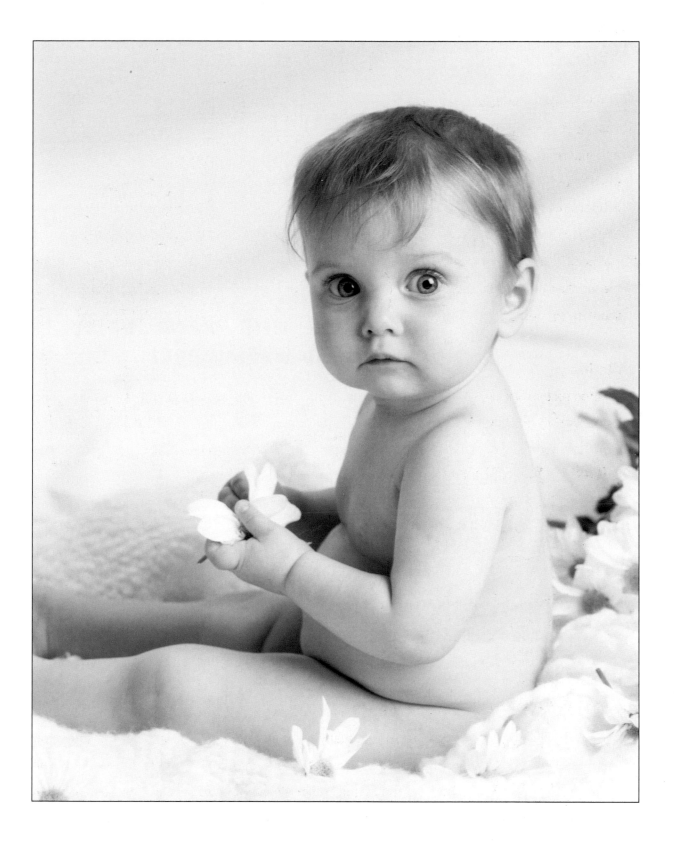

prop

This big metal tub is a prop from my studio that I use for both indoor and outdoor shots. Here, it's filled with a few inches of warm water to make a fun wading pool for this toddler. A few floating silk flowers add some texture and a sense of nature to the setup—and also give the toddler something to play with.

flexibility

This little girl was very happy playing in the wading pool, but if she hadn't enjoyed it, we would simply have gone on to something else. You have to stay very flexible when photographing kids.

lighting

The light for this image came from a large window to the left

It's filled with warm water to make a fun wading pool . . .

of the setup. This soft light wraps around the baby and tub, but creates just enough shadow to show the shape of the baby's belly, arms and chubby legs.

getting the shot

When working with kids, I'm usually handholding my camera and shooting on the fly as they move around. This requires shooting quite a bit of film—often two or three rolls to get the one shot I want. How much I shoot also depends, of course, on the package the client has selected and how confident I am that I have that winning shot.

seeing the face

Some people might be bothered that the baby's face isn't visible in this portrait. Since most of my clients buy more than one image, that isn't a problem. In this case, the family bought a collage of images from this series—this image, one with the baby looking at the camera and one of the baby from behind. These images were also printed in three different tones (light pink, light lavender and light green) and framed all together.

quick reference

CAMERA
Mamiya 645

LENS
110mm

FILM
Ilford XP2

METERED AT
$1/125$ second, f/5.6

EXPOSED AT
$1/125$ second, f/2.8 $1/2$

OVEREXPOSED BY
$1 1/2$ stop

LIGHTING
window light

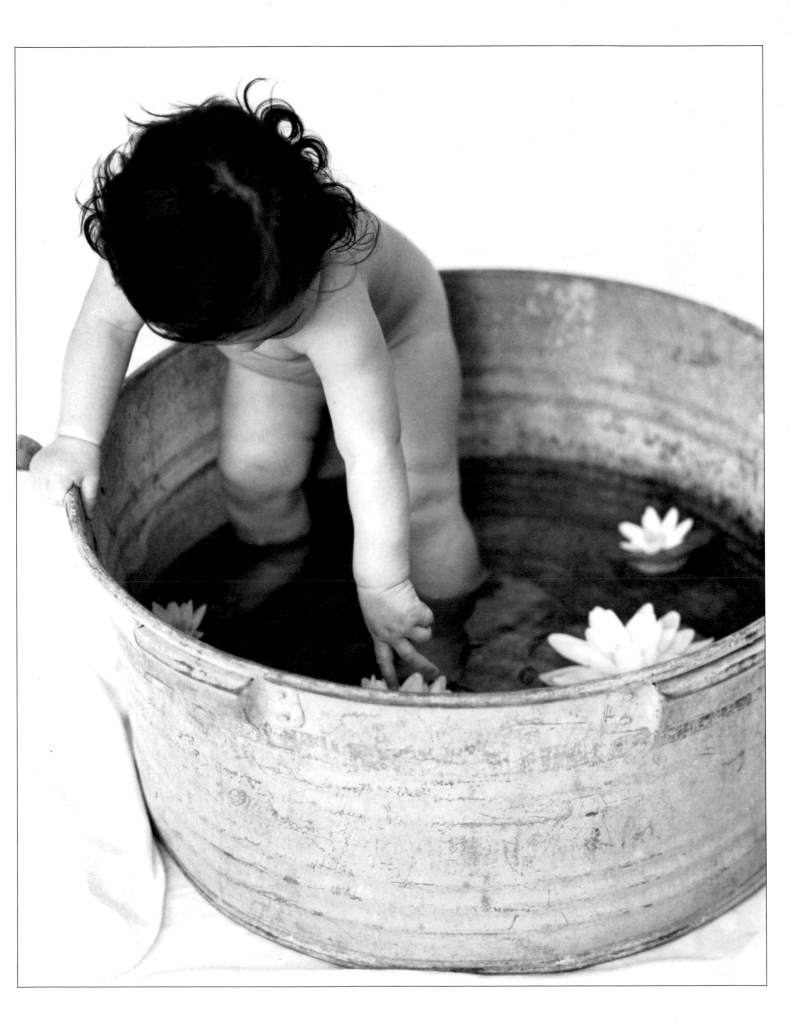

FAIRY GIRL

concept

In my consultation with her parents, we decided to create a portrait of theis little girl as a wild fairy. The idea was well suited to the subject, who had long natural hair and delicate features with a certain fairy-like quality to them.

hair

I wanted a natural, foresty look, so I styled the little girl's hair to look a little messed up.

quick reference

CAMERA
Mamiya 645

LENS
150mm

FILTER
81C

FILM
Konica 3200

METERED AT
$1/500$ second, f/16

EXPOSED AT
$1/500$ second, f/8

OVEREXPOSED BY
two stops

LIGHTING
available late afternoon light
from open sky

In general, I don't like for kids' hair to look excessively groomed. Unless the shot calls for a very neat and tidy look, I really prefer to see their hair as it probably is most of the time—a little bit messed up.

clothing

The costume worn by this little girl is one I designed myself and had made by a tailor that I work with. The wings are supported by a flexible wire frame. The headpiece was made to go along with the costume, and simply consists of dried flowers and leaves. In her right hand she holds a similar cluster of dried flowers and leaves.

setting

This portrait was created in a nearby park. The girl was posed on a hill, so the grass behind her filled the entire background of the image.

lighting

This image was created using late afternoon light on an overcast day. The sunlight came from the right of the frame, and her face was turned into the light for even illumination.

I selected ASA 3200 film to create a soft, painterly feel . . .

film selection

I selected ASA 3200 film primarily to create a soft, painterly feel, but the grainy look also worked well with the light. Because the light was very flat, the image would probably have looked dull with a slower speed film. With high speed film, the grain turned what could have been dull into a softness that works well.

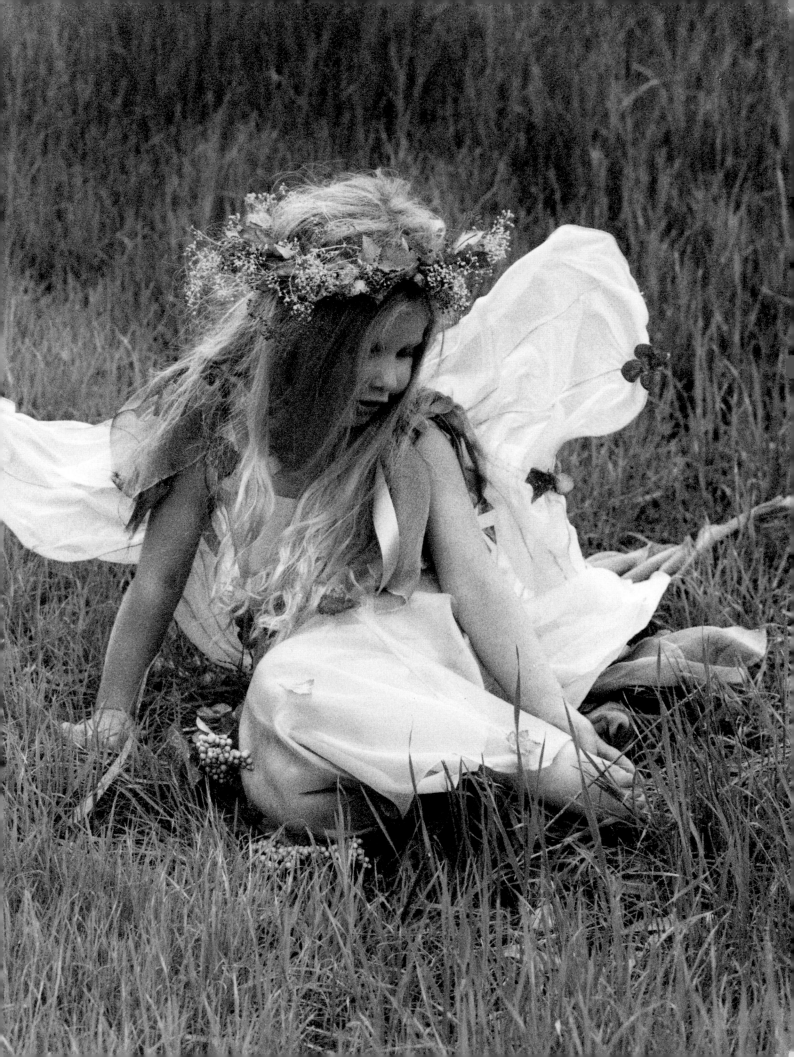

INTERACTION

concept

I photographed this little boy in the yard behind my parent's house. He was seated in a rather rustic-looking twig chair in their garden.

lighting

I placed the boy in an area where soft, even light fell on him. This allowed him to move around without ever getting into a bad lighting situation.

interaction

Once the boy was seated in the chair, I asked him to play patty-cake and peek-a-boo. This kind of interaction is crucial for getting natural looking images. Giving a child something to do keeps his mind off the photography, so he can just be himself.

printing

Sepia toning helped to accent the portrait's earthy character.

quick reference

CAMERA
Mamiya 645

LENS
150mm

FILM
Ilford XP-2

METERED AT
$1/125$ second, f/11

EXPOSED AT
$1/125$ second, f/8

OVEREXPOSED BY
one stop

SPECIAL PRINTING
sepia tone

LIGHTING
available light, open shade

EXPRESSION

expression

It's hard for kids (and many adults) to smile on cue and look natural. This is another reason that handholding and shooting on the fly is helpful—it makes it easier to capture that perfect natural moment when I see it. Great portraits are all about clicking the shutter at the right moment. To help get more of these "right moments," I talk with the kids—say funny words, tell a silly joke, or ask them what their favorite flavor of ice cream is.

I also like to enlist the help of the parents, who are generally right nearby. I'll tell the child style (sort of a J.Crew® look). I find it can be helpful to refer to well-known advertising (like Calvin Klein®, Gap®, Bebe®, etc.) when discussing the style of images that my clients want.

Great portraits are about clicking the shutter at the right moment.

"Look at Daddy—Daddy's going to jump up and down!" or "Daddy's going to sing a song for you!" This gets the parents a little more involved and can produce nice expressions on the child.

location

This image was shot in a local park. If you plan to take portraits in the park, be sure to consult with the park office about special permits or arrangements you may need to make to do so.

concept

The parents wanted an image with a contemporary magazine

The familiarity of these styles provides an instant point of reference and helps us discuss more clearly what kind of portraits they would like.

clothing and prop

The little boy's khakis were perfect for the all-American look we wanted to create. The concept was completed by this canvas chair that I supplied from my studio props. Using a prop like this is helpful for little kids, as it gives them something to be involved with during the photography.

quick reference

CAMERA
Mamiya 645

LENS
150mm

FILM
Ilford XP2

METERED AT
$1/125$ second, f/8

EXPOSED AT
$1/125$ second, f/5.6

OVEREXPOSED BY
one stop

SPECIAL PRINTING
sepia toned

LIGHTING
available late afternoon light filtered through white silk

FILM SPEED

Setting

This portrait of the client's son was done at her home in an antique bathtub. Using window light for a simple, natural look, I photographed this little boy, his brother and the two boys together. There were a lot of great images from the shoot, but the expression in this image seemed particularly engaging.

technical perfection

When shooting with high speed film, here ASA 3200, you get a lot of contrast—often to the point of losing detail in the highlights. While this might bother a judge in a print competition, it doesn't really worry me. There are a lot of other things that seem much more important to me.

Here, the expression, the pose and the composition work together so well that losing a little detail in the highlights doesn't seem like a big deal at all. Also, the grain adds an older feel to the image. This complements the style of the antique bathtub.

Once you start getting too wrapped up in technical perfection, I think you risk losing the freedom and spontaneity of what you're doing because you're trying to control things too much.

metering

To keep the skin tones light and clean, I metered off his skin tones in the area just under the little boy's chin.

The grain adds an older feel to the image . . .

quick reference

CAMERA
Canon EOS

LENS
80mm

FILM
Kodak TMAX 3200

METERED AT
$\frac{1}{250}$ second, f/8

EXPOSED AT
$\frac{1}{250}$ second, f/4.5

OVEREXPOSED BY
$1\frac{1}{2}$ stop

LIGHTING
available light

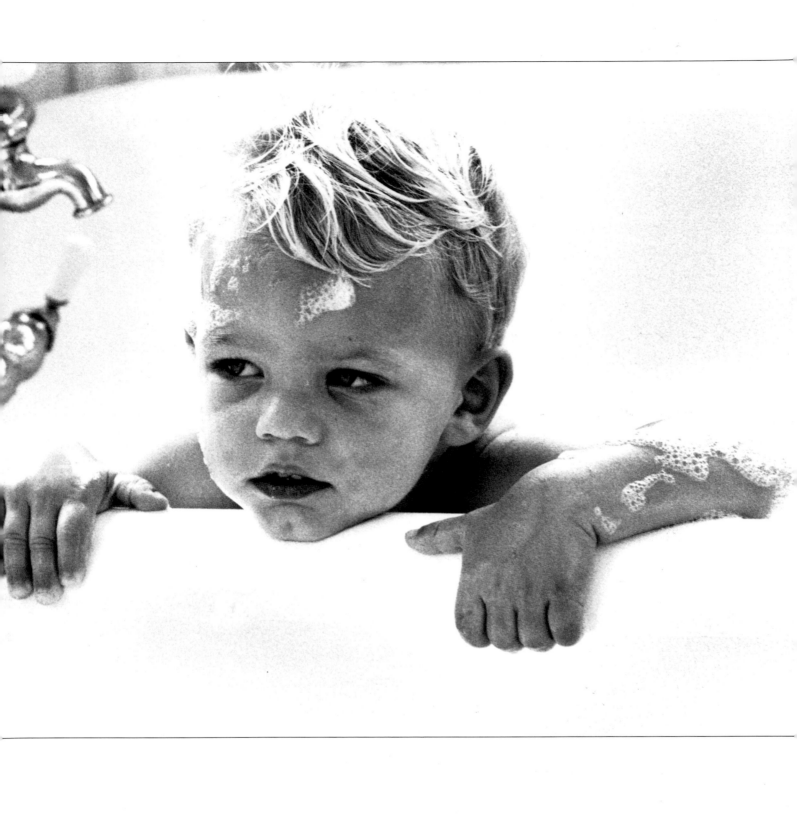

PROPS

location

This portrait was created at the beach, in a green area off to the side from the sandy shore. I find this area is a great place to shoot family portraits because I can do group portraits on the beach and then bring individuals—moms, dads and kids—aside to this green area for a totally different look. This allows me to achieve a wider variety of images without having to move very far.

quick reference

CAMERA
Mamiya 645

LENS
150mm

FILM
Ilford XP2

METERED AT
$1/125$ second, f/11

EXPOSED AT
$1/125$ second, f/8

OVEREXPOSED BY
one stop

SPECIAL PRINTING
green tint

LIGHTING
available light in open shade

family portraits

For this shoot, I did the family portraits with the whole group together, and then started working with the mom and dad and the kids individually. Providing this variety of images in visually unique locations increases the sale, and clients like it because the collection of images tell a little story of their day together on the beach.

props

The girl came to the shoot in this dress, and I provided the flowery headpiece. In her hands she holds a daisy. This is something her parents brought along with them to the session. I often ask clients to bring flowers or other items along with them as props. In this case, flowers seemed very appropriate to the natural, earthy quality we were seeking in the fam-

ily's portraits. Holding it also gives the little girl something very sweet and natural to do with her hands.

printing

This portrait is toned in green. While this isn't a common color in which to see skin tones, it

Flowers seemed very appropriate to the natural, earthy quality . . .

seemed to suit the earthy character of the image. Because it makes the leaves green, the coloration also helps to suggest the rich, natural hue of the foliage.

concept

This little girl had very powerful, engaging eyes, and I knew that was what I wanted to emphasize in her portrait. Capturing this serious expression with her looking directly into the camera reflects that effectively.

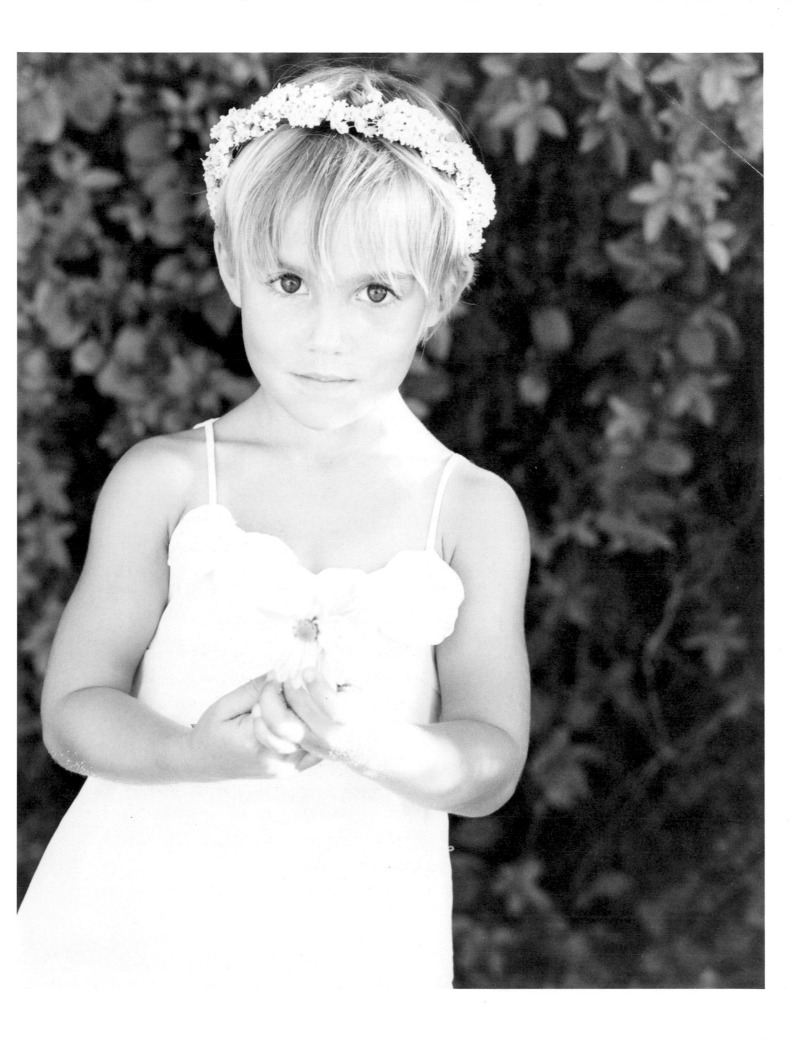

HANDCOLORING

Concept

These two little sisters were close in age, so I wanted to show them giggling and playing together. Their sweet expressions and affectionate pose really show the love they have for each other.

Set

The portrait was created in my studio using natural window light. The little girls were laying down on a white sheet next

to the window, which was to their left. Surrounding the girls were a number of silk flowers.

posing

As I've noted, when working with kids, I use prompts and games (rather than specific directions to do this or that) to get the natural poses and expressions I want. Here, I wanted a soft, cuddly feel, so I asked them to kiss each other, to hug, to share a secret. In some shots, they are giggling, but I ultimately preferred this version, which shows the girls' soft and engaging expressions.

handcoloring

The image works well as a straight black & white print, but looks especially good with a little handcoloring on the flowers. This adds a soft, classically feminine quality to the image without overwhelming the little girls.

quick reference

CAMERA
Mamiya 645

LENS
110mm

FILM
Ilford XP2

METERED AT
$^1/_{125}$ second, f/8

EXPOSED AT
$^1/_{125}$ second, f/5.6

OVEREXPOSED BY
one stop

SPECIAL PRINTING
handcoloring on flowers
in large image

LIGHTING
window light

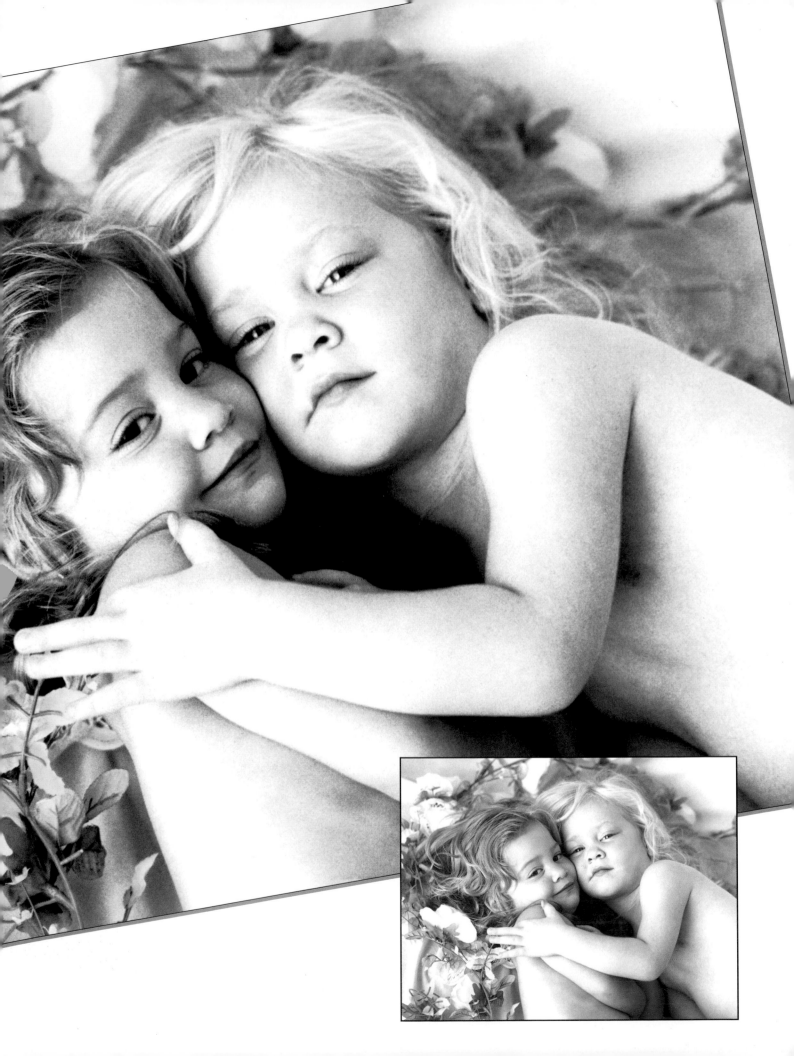

IN COSTUME

concept

I've been photographing this little boy since he was a baby (in fact, this is the same boy shown in the portrait on page 29). For this portrait, he wanted to dress up like a cowboy. So, instead of doing a goofy Halloween-type portrait, we decided to make it look real. His parents provided this excellent costume. The chair was a prop I had in my studio,

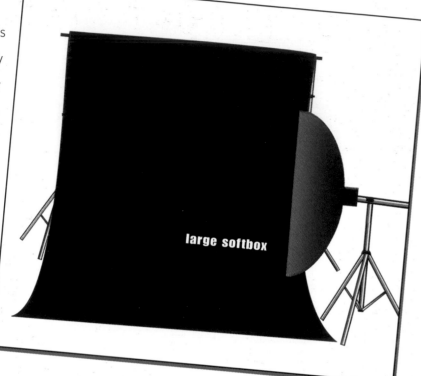

large softbox

quick reference

CAMERA
Mamiya 645

LENS
110mm

FILM
Kodak TMAX 100

METERED AT
$1/60$ second, f/11

EXPOSED AT
$1/60$ second, f/8

OVEREXPOSED BY
one stop

SPECIAL PRINTING
sepia tone

LIGHTING
large softbox low
and directly to the right
(see diagram)

and its worn texture fit the old-time look of the costume.

lighting

I wanted a dramatic look for the lighting, so I used a single softbox, placed rather low and almost directly to the boy's right. The effect is almost like light through an open door. The light skims across his face and body, revealing their shapes and the great textures of the costume.

posing

This is a pretty charismatic little boy, so posing him to look like a tough cowboy wasn't hard—we just interacted until I had the look I wanted.

printing

A sepia tone was selected for this image to reinforce the "old west" feel of the portrait.

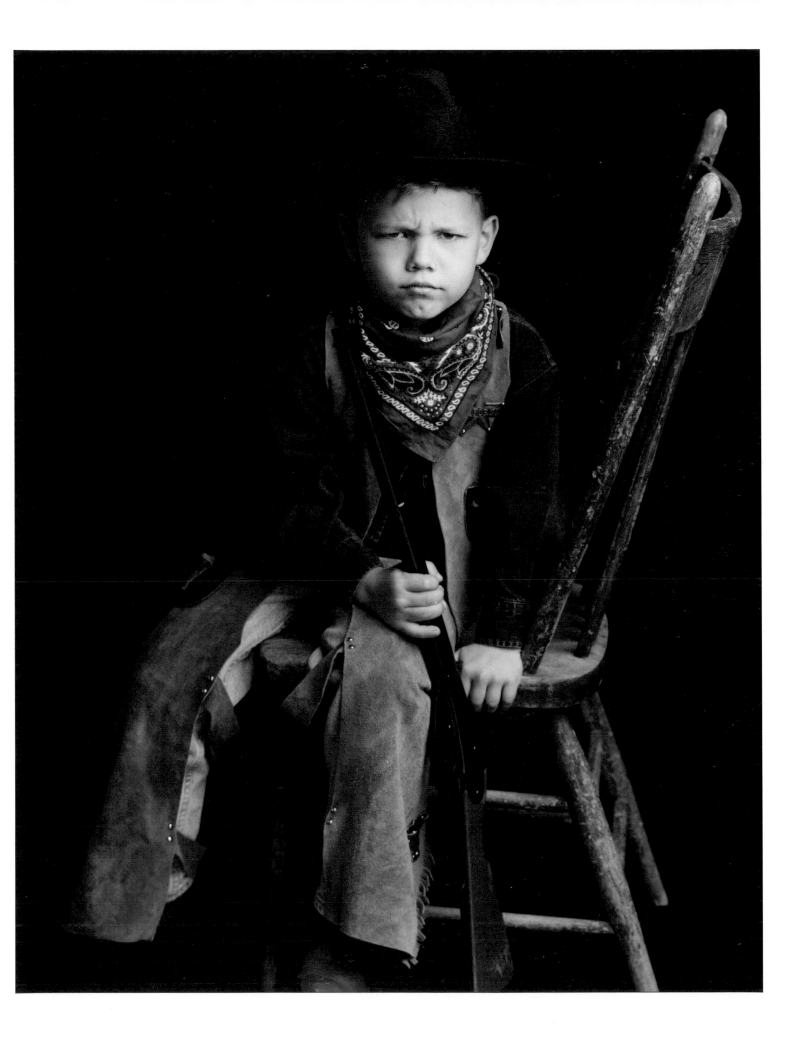

setting

This image was created at the very end of a shoot in which I had photographed the mom and her five kids. At the very end of the shoot I just happened to notice the baby on the mom's shoulder. It was a totally unplanned image; I just saw it, zoomed in and got the photo.

It just goes to show you, it really pays to keep your eyes wide open during a shoot. Sometimes, the real stand-out photographs from a session can be the ones you never planned and least expected.

clothing

The baby's face was surrounded by soft, white fabrics. The mom was wearing a white sweater,

It really pays to keep your eyes wide open during a shoot.

which you see in the lower half of the image. The baby had a lamb's wool hood up around his face.

a favorite image

Although this photo is now several years old, its classic look guarantees it will never look its age. I display this image as a 30" x 40" print in my studio. Looking at it is almost like looking into the soul of a baby. His eyes are deep and bright, his lips and nose are delicately lit to show their shape, and his skin is smooth and flawless.

exposure and printing

This image was one stop overexposed to make the whites bright and the skin tones light and clean. Rather than toning it, this image is shown in traditional black & white to preserve the clean look of those white areas.

quick reference

CAMERA
Mamiya 645

LENS
150mm

FILM
Ilford XP2

METERED AT
$1/125$ second, $f/5.6$

EXPOSED AT
$1/125$ second, $f/4$

OVEREXPOSED BY
one stop

LIGHTING
available light at the beach

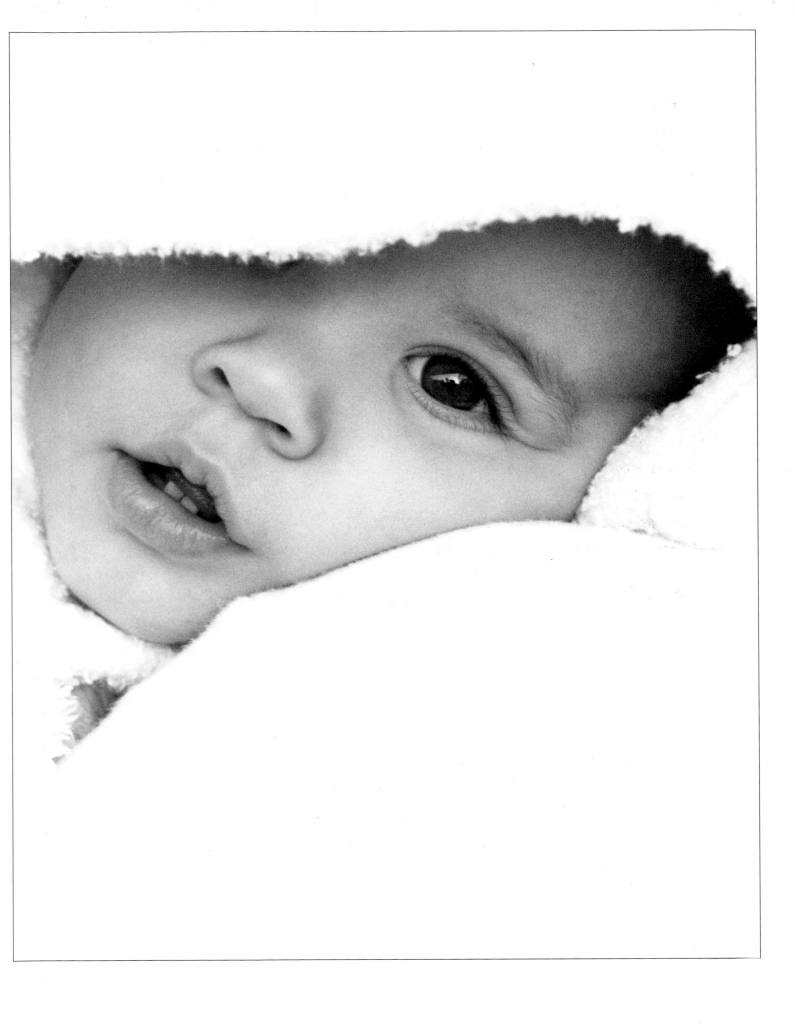

DANCING PRINCESS

location

This portrait was created in the backyard of my studio near a green ivy-covered wall.

lighting

For this image, we worked in direct sunlight, which comes from above and behind the girl. A 4' white fill card was placed in front of her to bounce light onto her face and the front of her body. When you use a reflector, make sure to pay attention to your client's eyes. Some people tend to squint when light is bounced into their face like this. Your client would

This also contributed to the fairy-tale quality of the image.

much rather have a little less light on the subject's face than a squinting expression.

posing

Here, I asked the girl to spin around—a very typical thing for a little girl to do in a dress with a full skirt. This also contributed to the fairy-tale quality of the image. As she spun, I snapped off frames each time she came around to face me.

clothing

The little girl wore a special dress that her mother brought with her to the session. With the flower and ribbons in her hair, she looked like a little princess.

Metering

When shooting handheld and on the fly, you obviously can't meter every frame. Therefore, metering becomes one of my assistant's jobs. Once we've worked in an area with a client for a little while, I can pretty much tell that the exposure in place B should be the same as it was in place A—or how it might need to be different.

printing

This portrait was printed in a magenta tone—a color that seemed to work well with the photo and suggests the fairy-tale quality of the little dancing princess. We also offer toning as a selling point, suggesting colors that will match the client's home. A print like this, for example, might look great in a room with lavender décor.

quick reference

CAMERA
Mamiya 645

LENS
150mm

FILM
Ilford XP2

METERED AT
$1/250$ second, f/11

EXPOSED AT
$1/250$ second, f/8

OVEREXPOSED BY
one stop

SPECIAL PRINTING
magenta tone

LIGHTING
available light
with white fill card

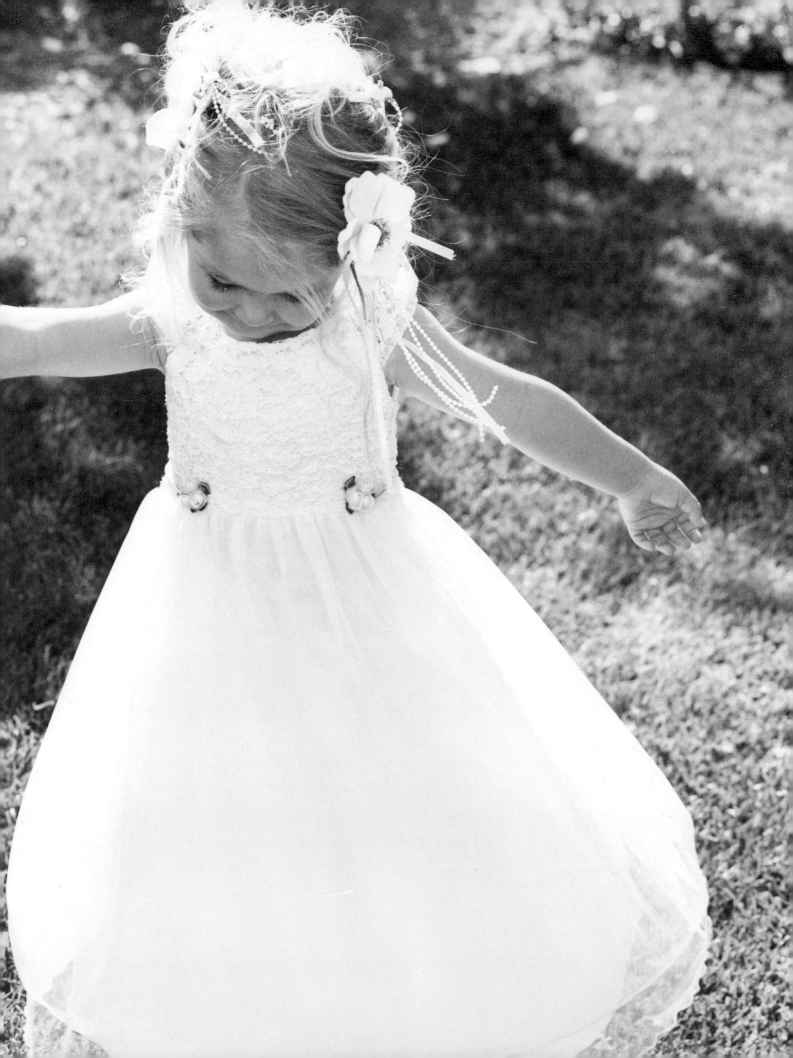

BIRTHDAY PORTRAIT

concept

This is a portrait of my little girl, Skyler, on her first birthday. She's holding one balloon to indicate that she is one year old.

lighting

One large softbox was placed above and slightly to the right of the subject. This light illuminated both her and the light blue seamless paper behind her. Because the softbox lights the whole area, it works well for active little kids who are always moving around. It gives them some space to move around without wandering out of the desired lighting.

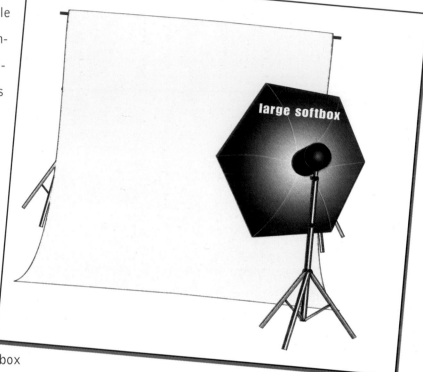

clothing and set

We picked out this little light blue dress for the shoot and then built the rest of this image around it, with a light blue backdrop, blue bow in her hair, and clear balloon with a blue ribbon. I like the monochrome effect with little kids. By keeping everything in one color, you can really help little ones to stand out in the frame.

The series of three images shown on the next two pages were taken on the same day.

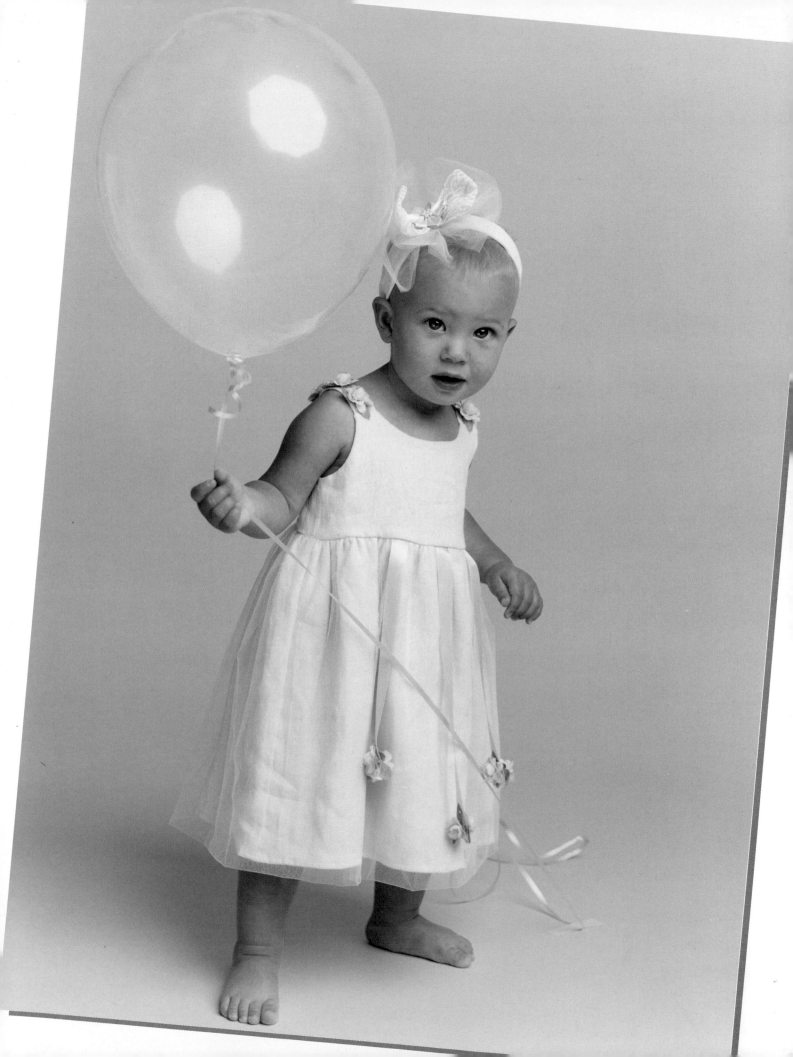

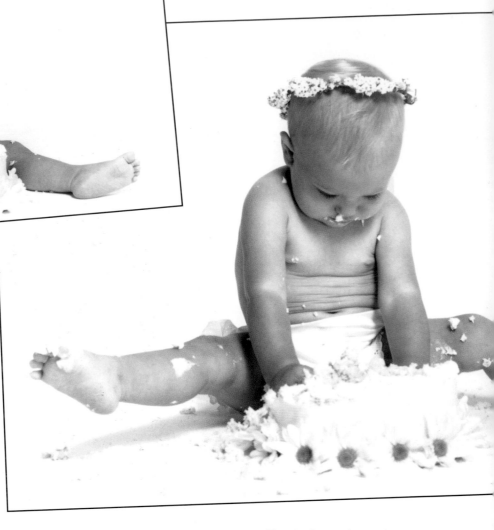

S E Q U E N C E S

sequences

For this first-birthday portrait, I sat my daughter down with her first cake, and shot as I watched what she did with it!

quick reference

CAMERA
Mamiya 645

LENS
150mm

FILM
Kodak TMAX 100

METERED AT
1/60 second, f/16

EXPOSED AT
1/60 second, f/11

OVEREXPOSED BY
one stop

LIGHTING
large silver umbrella overhead,
strip light on background

sequences

I sell a lot of grouped images of kids—they do so many cute things that one print often just isn't enough. Sequences like this one (of my own daughter's first birthday) can be framed together very effectively to create a little movie of the child. One image couldn't tell the story as effectively as the entire series can.

set

The backdrop was disposable white paper. A few daisies were added on the cake, along with a wreath of flowers on her head. Otherwise, the image is all one year old.

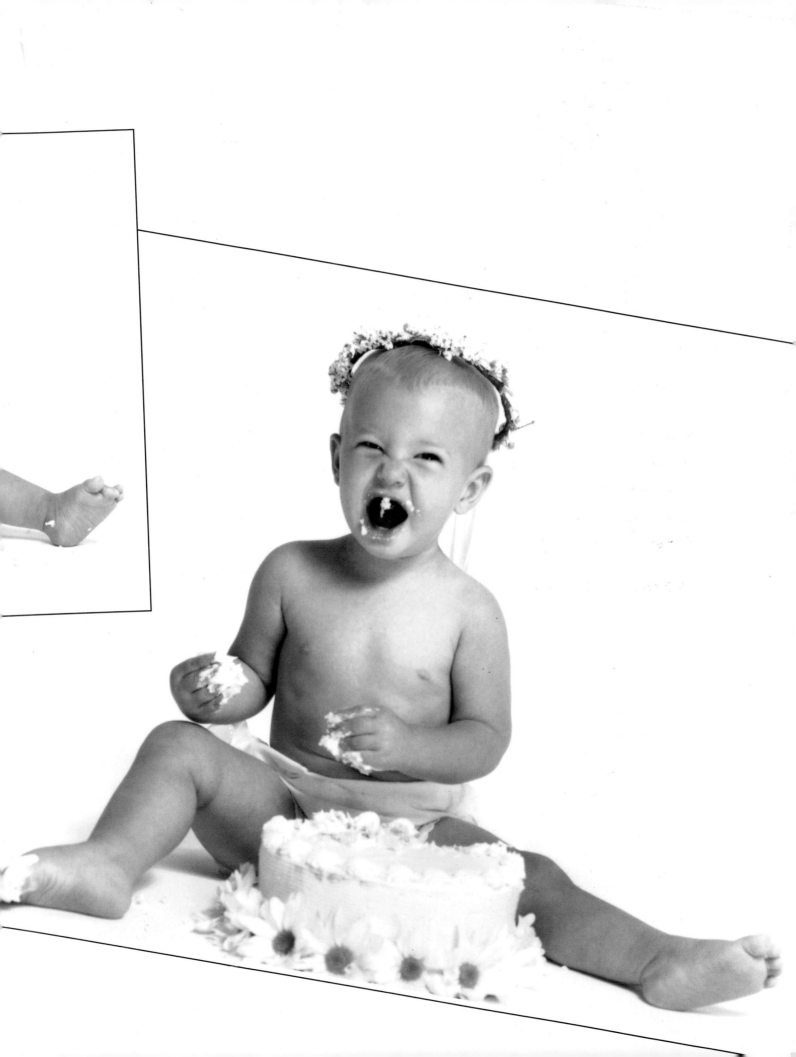

special concept

When I met with the clients for their consultation, they brought along some images by an artist they liked. I don't remember the artist's name, but all of his paintings were richly colored images of twilight. I was excited about trying to create this same look in their portrait.

special concept

This image of the couple's children was created in their

tungsten light inside house

spot with blue gel

softbox with warming gel

quick reference

CAMERA
Mamiya 645

LENS
110mm

FILTER
81B

FILM
Fuji NGHII

METERED AT
¼ second, f/5.6

EXPOSED AT
¼ second, f/5.6

LIGHTING
soft box with warming gel,
candles, tungsten light in house,
background light with blue gel
(see diagram)

own backyard. The clients provided extra candles and flowers to dress up the area for a more magical feeling.

posing

I wanted to create an intimate feel that was appropriate for the fairy-tale setting. After trying a few different ideas, I came up with having the pair look down into a candle in the girl's hand. The dreamy, far-off expressions on their faces work perfectly in the shot.

lighting

The warm tone of the candles and tungsten light in the house was reinforced by the use of a warming filter on the softbox that served as the main light. A blue gel on the background light completes the blue and gold look of twilight.

Polaroids®

Shooting lot of test Polaroids was the key to finding the right exposure on this shot.

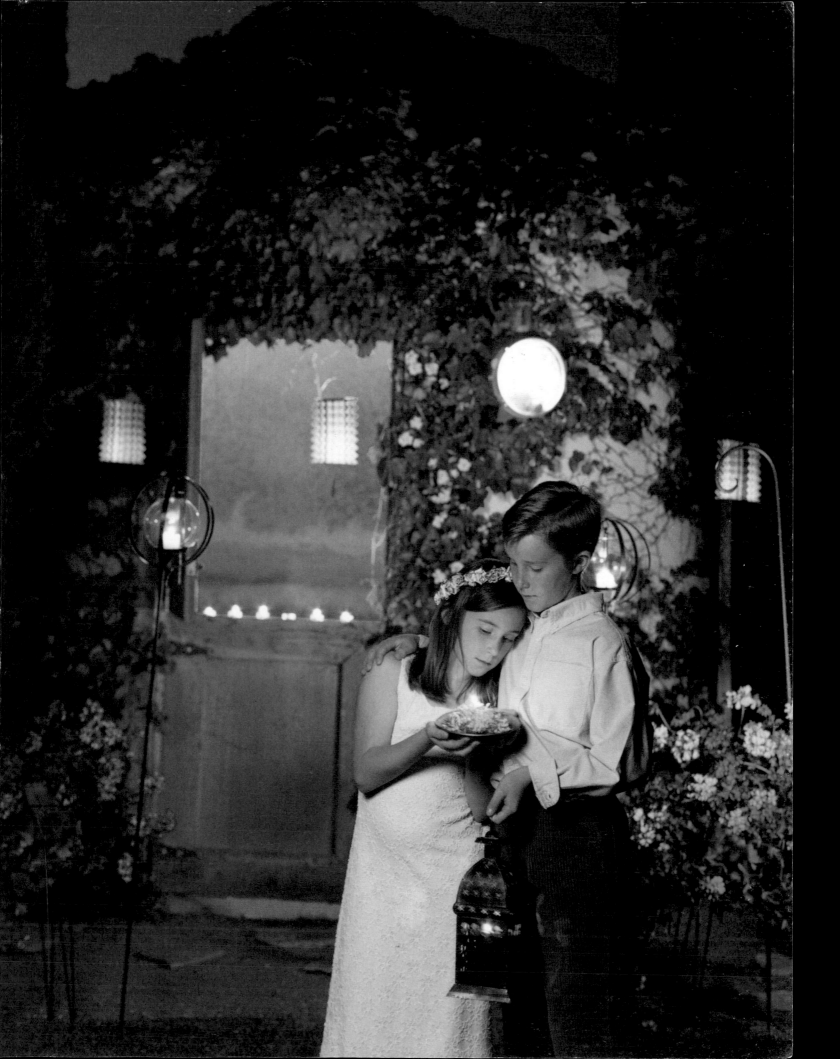

BROTHERS

concept

The two brothers were great subjects—full of energy and totally cooperative. I wanted to capture the spirit and energy of these two little boys in their portrait.

lighting

I worked using natural window light and with the boys on a simple white backdrop. This ensured that I could let them move around and be themselves without having to worry about repositioning any props or lighting equipment. I placed an eggcrate foam cushion underneath the area so they would be comfortable.

simplicity

In addition to creating an easy shooting environment, the soft, simple lighting and clean white background lets these two great faces be the real stars of the portrait. Additionally, the boys took off their shirts, creating an even more uncluttered look.

posing

As I've noted, when I photograph kids, I try to interact with them constantly and I shoot a lot of film—ensuring I get that great shot their mom and dad will love. There were a lot of great shots of these adorable boys, as I asked them to tickle each other and such. One of the best though, came when I asked the big brother to put his head on top of his little brother's head. As you can see, the result is a portrait of two lively little boys with happy expressions that are totally natural and spontaneous.

printing

The blue tone of the image completes the boyish look.

I wanted to capture the spirit and energy of these two little boys.

quick reference

CAMERA
Mamiya 645

LENS
150mm

FILM
Ilford XP2

METERED AT
$1/125$ second, f/8

EXPOSED AT
$1/125$ second, f/5.6

OVEREXPOSED BY
one stop

SPECIAL PRINTING
blue tone

LIGHTING
available light

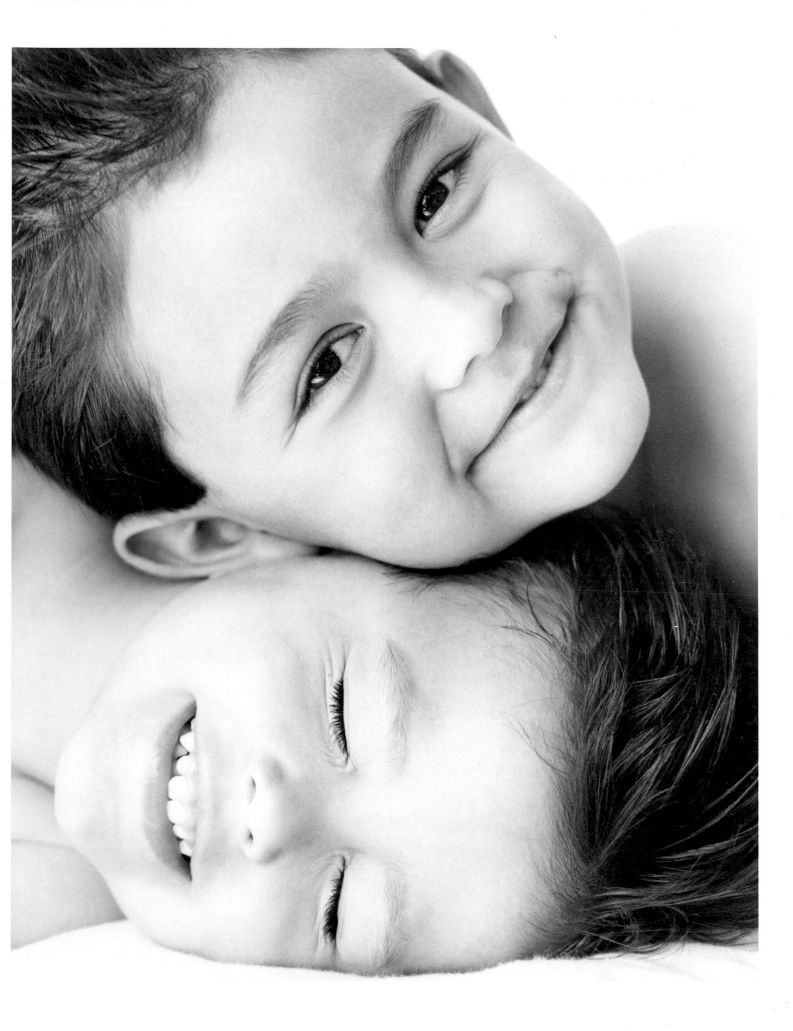

SECTION

2

MEN

concept

This image was taken while I was in Paris on another job. I had been wanting to do another shoot while I was there, so when I met this man I asked him if he'd like to be photographed. As it turned out, he was actually a professional model.

lighting

We took this image in a park on a cold day during a light rain. Natural light was used for the shot, but the day was very dreary so the light was quite low.

location

I had walked around in this beautiful park the day before, so I thought of this location immediately. I liked the way the lines of trees receded into the background. Chairs like this were placed throughout the park, so it seemed natural to pose him in one of them.

composition

This rather dramatic composition is full of diagonal lines. The two lines of trees recede back from the edge of the frame. The subject is also tilted back in the chair, creating more diagonals and placing his face at the intersection of the two lines of trees. His left knee is lifted, creating another diagonal.

Polaroid

Using the Polaroid 665 positive/negative film created the worn, imperfect look I wanted. With its characteristic lumpy and uneven border, the film was integral to the final look of the image.

The film was integral to the final look of the image.

quick reference

CAMERA
Polaroid

FILM
Polaroid 665 positive/negative

LIGHTING
available light

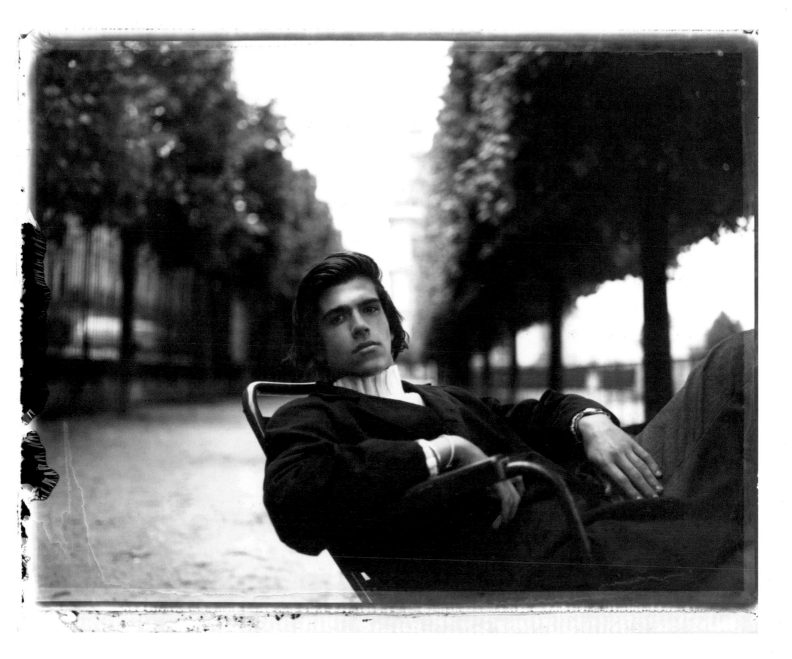

VINTAGE LOOK

concept

This image was created for a model. He wanted some images with a vintage 1970s look. With his hair and sideburns, this was a very effective look for him. The jeans, t-shirt and funky jacket completed the period look.

location

We shot this image on the street, using the chain-link fence at a construction site as the backdrop.

quick reference

CAMERA
Canon EOS

LENS
200mm

FILTER
81C

FILM
Fuji Color 1600

METERED AT
$1/500$ second, f/11

EXPOSED AT
$1/500$ second, f/5.6

OVEREXPOSED BY
two stops

LIGHTING
available light

composition

The plants and flowers around him add a little texture and match the colors in his clothing. They were part of the reason I selected this setting. The plant on the right and the pole in the fence on the left also help to frame the model and draw the viewer's eye right to where I want them to look—his face.

lighting

This portrait was created using natural light. The sun was behind and the model and to the right. This backlighting creates nice highlights in his hair, and a rim lighting effect that outlines his shoulders.

film selection

The use of ASA 1600 film gives the image a nice grain. This matches the texture of his hair and jacket, and adds a little

more of the vintage feel we were trying to achieve.

exposure

Because the subject was back-lit, extra care was taken to achieve the correct exposure. I

He wanted some images with a vintage 1970s look.

didn't want the skin tones on the shadow side of his face to be too dark, so I metered for this area, then overexposed the image by two stops.

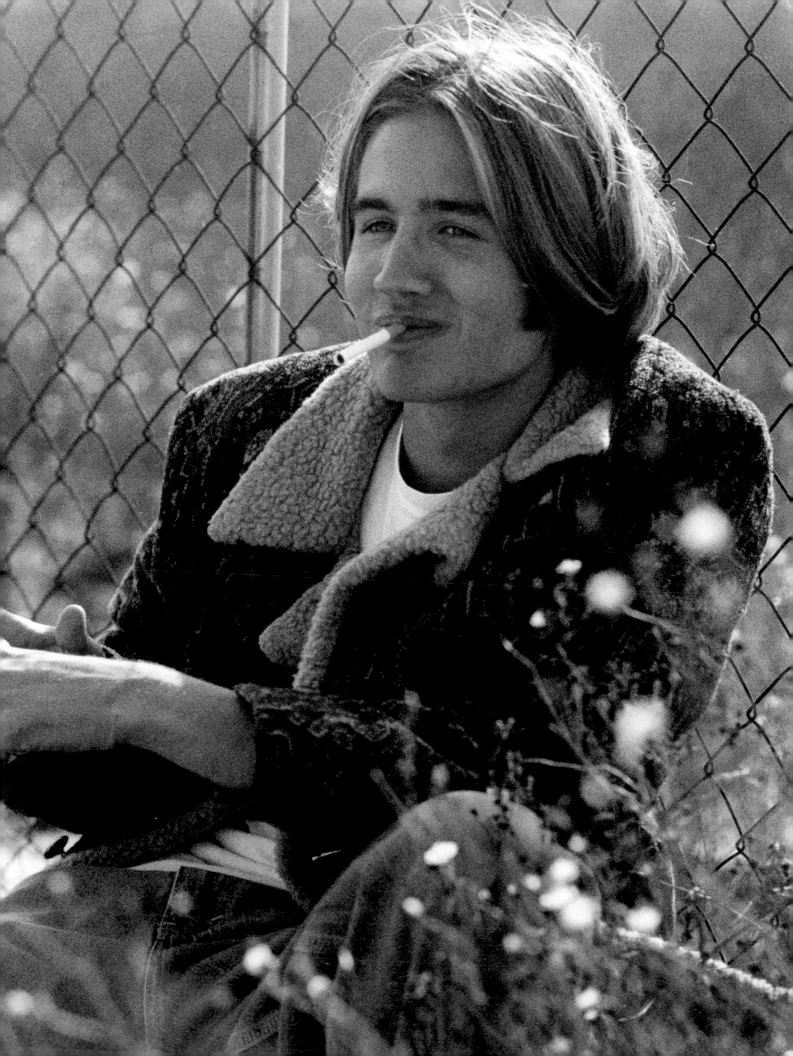

CANDIDS

concept

This portrait was created for a model. We had done some images for his portfolio before, and scheduled this session to do some new portraits to update it. He wanted a look something like the style used in ads by Abercrombie & Fitch®.

This image was actually the model's idea. We did a lot of different images that day, and

quick reference

CAMERA
Mamiya 645

LENS
150mm

FILTER
81B

FILM
Kodak NC 400

METERED AT
$1/250$ second, f/11

EXPOSED AT
$1/250$ second, f/8
(high shutter speed to stop water in the air)

OVEREXPOSED BY
one stop

LIGHTING
available light with white/gold reflector

saved this one for last, since he would have to get wet.

setting

The image was taken in my backyard, where the model was seated in an old garden chair.

We basically used a hose to toss water at him. Because we needed to catch the water in motion around him, I used a fast shutter speed to freeze the motion.

film usage

With images that are created in a candid style, you always need to shoot quite a bit of film. In this case, I shot about thirty frames of the image, to ensure that all the elements (water, pose, expression, etc.) came together correctly in at least one frame.

This may seem like a lot of film, but this is an area where you

can't be stingy. After all, film is cheap when compared to your investment in time on a shoot. My attitude is that, if I can spend a few extra dollars and end up with a better picture, it's worth it.

film is cheap when compared to your investment in time . . .

lighting

The image was created using natural light and one reflector for fill. The sun was behind the model, which creates the nice highlights on his hair, arms and shoulders. Because I wanted a very crisp look, I used a gold reflector to bounce fill light onto the front of his body. This, combined with a one stop overexposure, opened up the shadows and kept his skin tones from getting too dark.

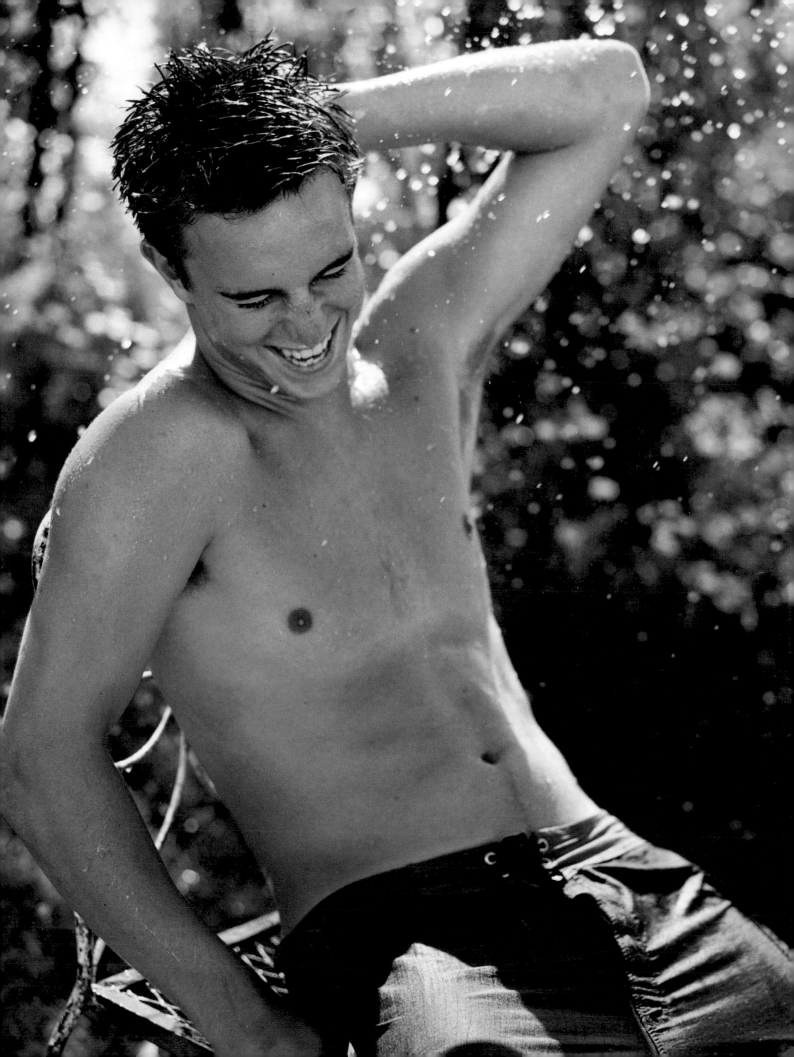

HOLLYWOOD STYLE

client

I shoot a lot of artist portraits, which are used in the artist's bio and when they do shows. When I photograph artists, I always ask them to bring in samples of their work so I can get a better sense of them and their style. This Italian artist had a very masculine style, so I tried to capture that sense in his portrait.

single spotlight

lighting

I used a single light—an old Fresnel movie spotlight fitted with a Speedtron head. This was placed high and to the right of the subject. I selected this light to create an image that is reminiscent of the classic black & white portraits of movie stars from Hollywood's golden age. Skimming across the subject, the light creates dramatic shadows that are deep and crisp.

lighting

This image was created in my studio. The subject was seated in a stuffed leather chair (once again, emphasizing that sense of masculinity), which was situated on a black backdrop.

quick reference

CAMERA
Mamiya 645

LENS
150mm

FILM
Kodak TMAX 100

METERED AT
$\frac{1}{60}$ second, f/8

EXPOSED AT
$\frac{1}{60}$ second, f/5.6

OVEREXPOSED BY
one stop

LIGHTING
single light high and
to the right (see diagram)

MEN

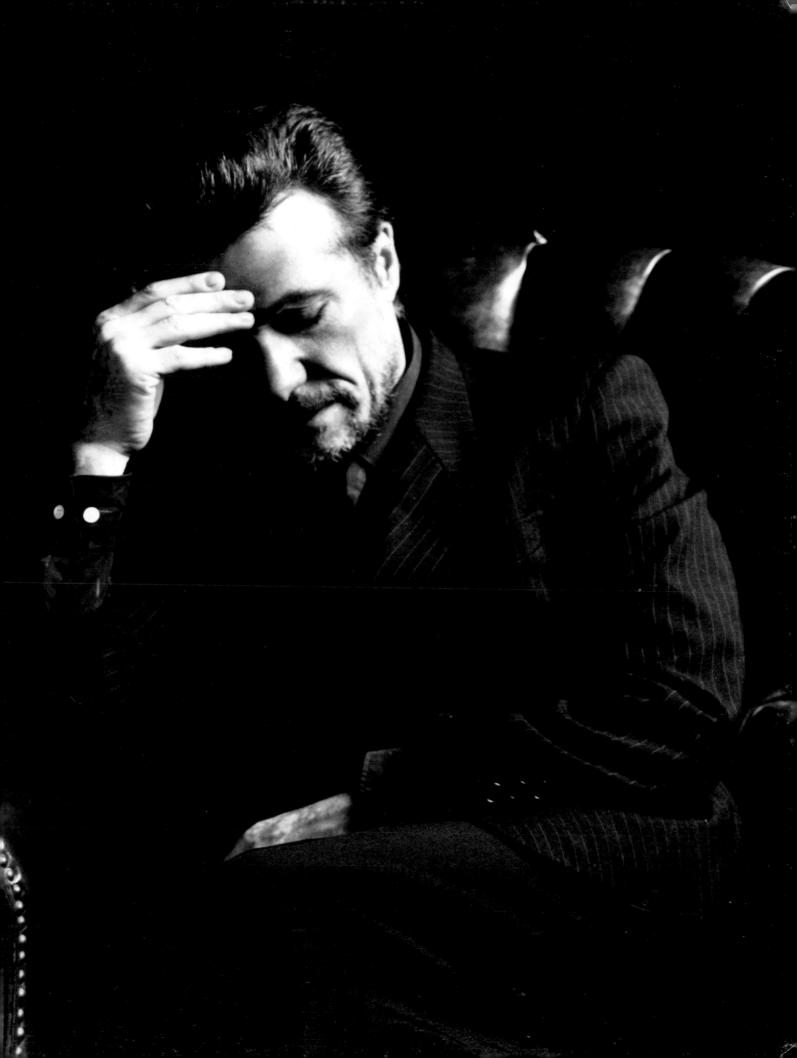

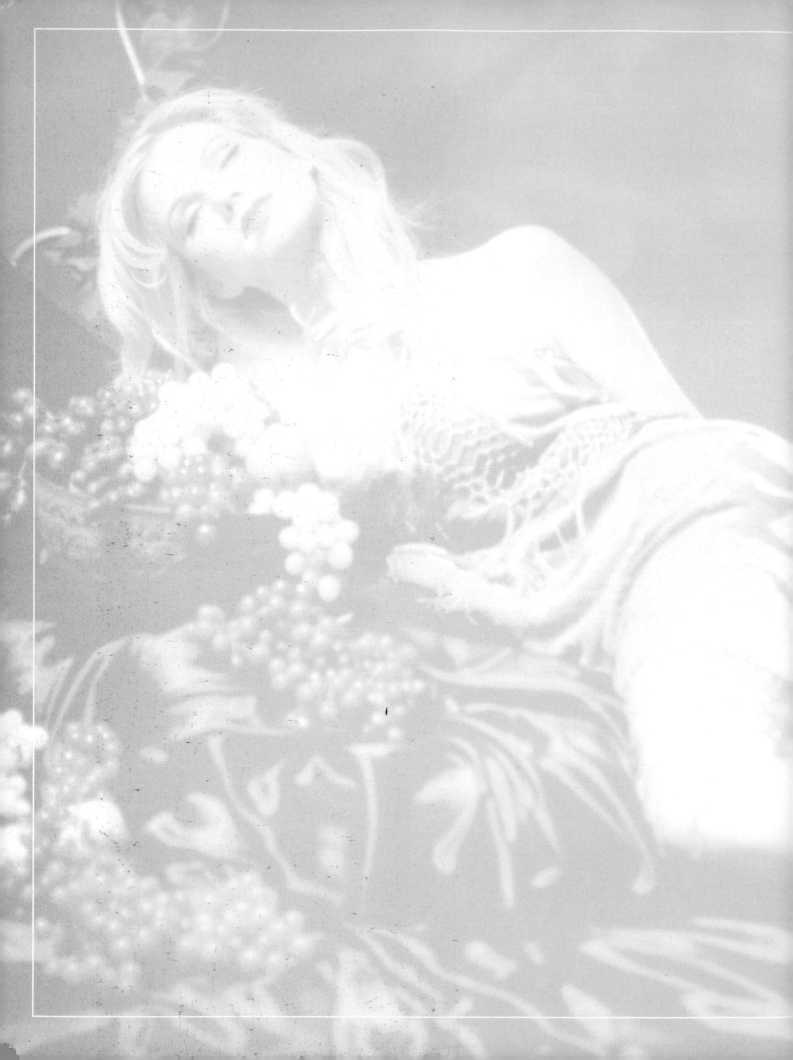

3

WOMEN

ON LOCATION

location

These images, taken for the model's portfolio, were created at an area about twenty minutes from my studio that is a little bit older and run down. It has a lot of character and interesting areas to shoot, with a dilapidated old store, overgrown trees and even this bus.

lighting

These portraits were taken on an overcast day, and a white fill card was used to bounce light onto the shadow side of the model. This extra light helped to open up the shadows on her face and add a little sparkle in her eyes.

attitude

To match the rugged look of the area, I worked with the model on creating a tough look.

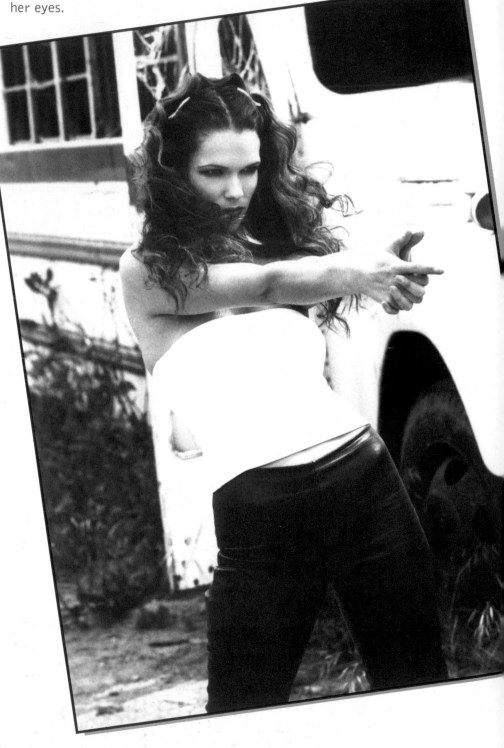

quick reference

CAMERA
Canon AZ

LENS
150mm

FILM
Kodak TMAX 3200

METERED AT
$1/1000$ second, f/11

EXPOSED AT
$1/1000$ second, f/5.6$1/2$

OVEREXPOSED BY
1$1/2$ stops

LIGHTING
available light with fill card

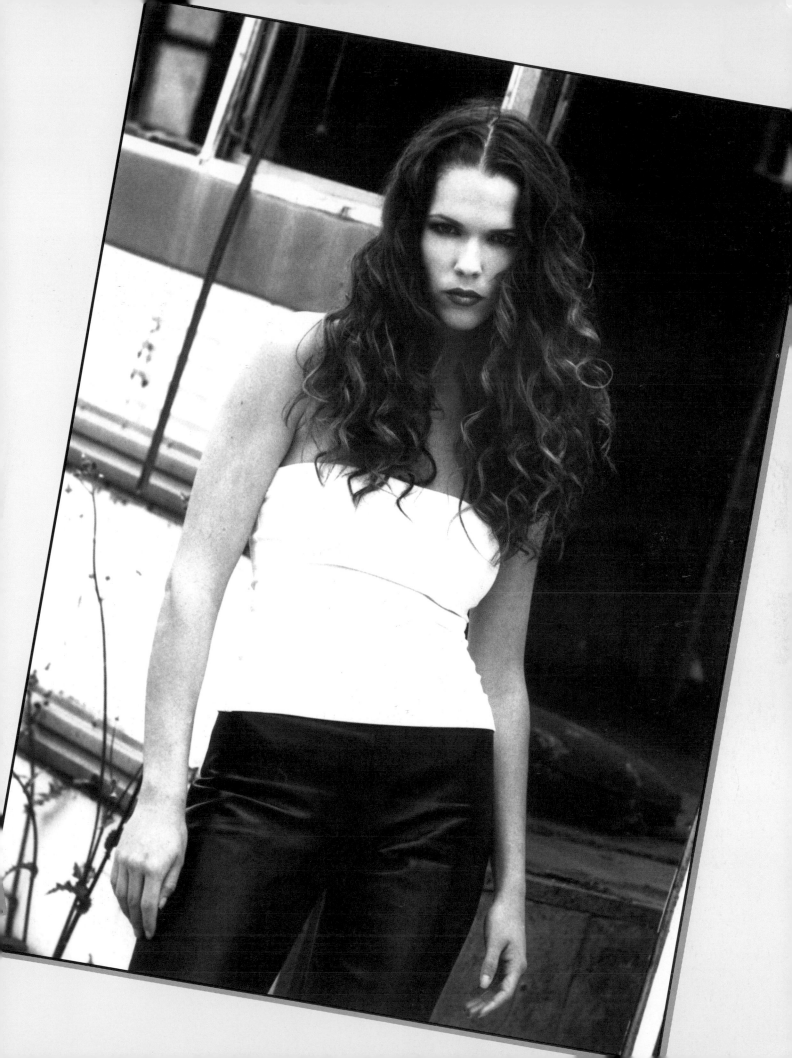

TEST SHOOTS

test shoots

I am always looking for new props, new poses and other new ideas to use with clients. Although sometimes it can't be avoided, I don't like ever having to make the same image twice. Generating new ideas takes a lot of active effort, however.

I am always looking at magazines and analyzing the images that I like. I

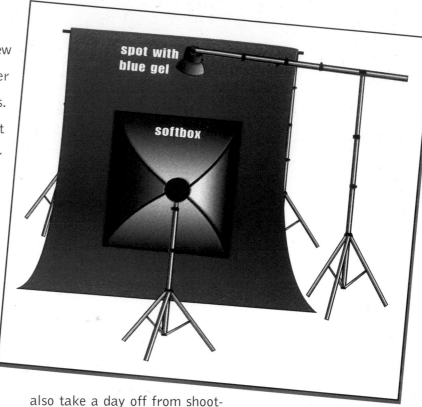

quick reference

also take a day off from shooting my clients every few months and do a test session with a model. I lose money that day, but it's a good trade-off for the new ideas I can bring to my sessions with clients.

concept

The concept for images in a test shoot often arise from the props or clothing in my studio. Here, I wanted to create an edgy look like the photos used by the store Bebe® in their advertising.

props

I spend a lot of money on props, because I think unique sets and props are a great way to make your images unique. Besides, I'd get bored if I had to look at the same chair day after day! As a result, I'm always on the lookout for unique items like this boldly patterned ottoman. You can find interesting props just about anywhere—from flea markets to furniture stores. Just keep your eyes open.

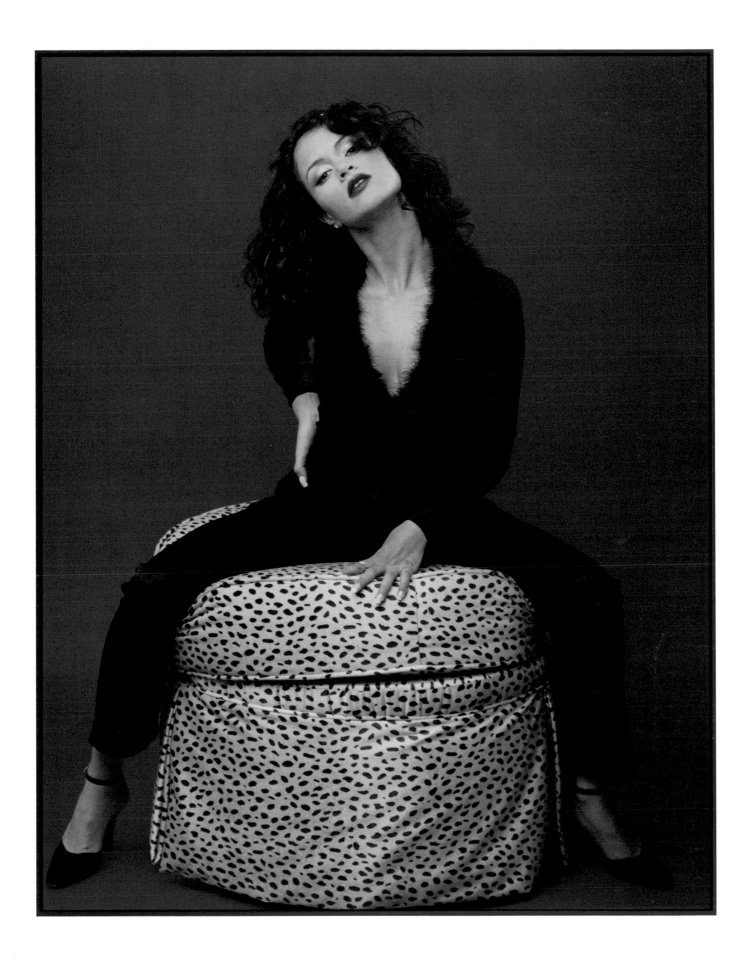

NATURAL AND SEXY

the shoot

The model is one of my friends—we actually did this shot in about ten minutes! We wanted to create a sexy, natural look, so the hair and makeup were styled accordingly.

backdrop

Here, the window that lights the subject is directly facing the black backdrop. Using a velvet backdrop helps to ensure that it reproduces as jet black in the

quick reference

CAMERA
Mamiya 645

LENS
150mm

FILM
Ilford XP2

METERED AT
$1/125$ second, f/8$1/2$

EXPOSED AT
$1/125$ second, f/5.6

OVEREXPOSED BY
$1^1/2$ stop

SPECIAL PRINTING
sepia tone

LIGHTING
window light

print. I also make sure to place it quite far back—about five feet—to ensure there won't be any problem with light catching on any wrinkles in the material.

When using colored backdrops (like seamless paper), I keep them quite close to the subject so that the backdrop's color will reproduce accurately.

makeup

While you can't create a "rule" to determine the right makeup, the makeup for black & white photography should be darker than for color. For a natural look in black & white, ask clients to apply their makeup as if they were going out at night. When I do a client's makeup, I begin by asking her about how she normally wears her makeup on her eyes and lips (light, medium, or dark), and then go a little darker than that.

posing

This pose, with the subject's arms framing her face, was flattering and suited the character of the portrait—a natu-

The sepia toning helps to accent the natural look of the portrait.

ral, sexy look. It draws attention to her intense expression, and bares just a little bit of her stomach. Working to achieve just the right pose with each client is an important aspect of providing high-end, magazine-style portraiture.

printing

The sepia toning helps to accent the natural look of the portrait and adds a nice warmth to the subject's skin tones. The model has beautiful red hair, so using the sepia tone also plays up the color of her hair.

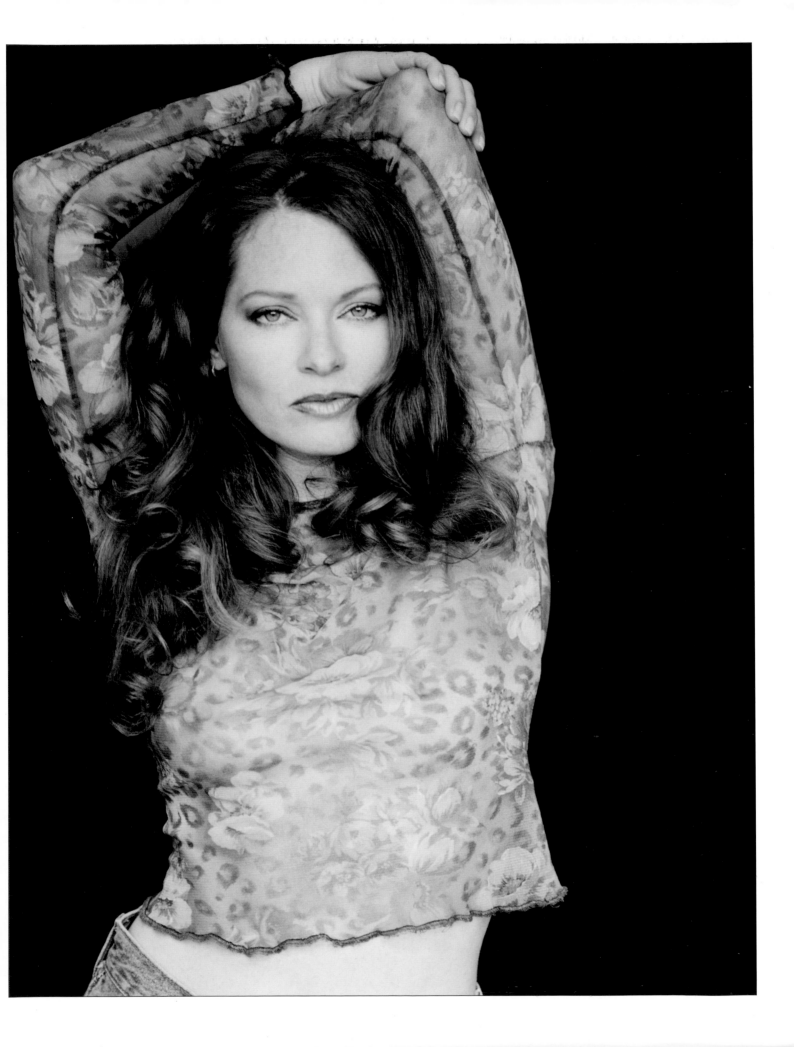

FANTASY

fantasy

As you can see throughout this book, I like creating images with fantasy or fairy-tale themes. These portraits are very unique and offer some emotion or connection that almost every viewer can identify with.

Working with this model, we wanted to create an image that made her look like a princess. For this reason, I chose this

quick reference

CAMERA
Mamiya 645

LENS
150mm

FILM
Ilford XP2

METERED AT
$1/250$ second, f/8

EXPOSED AT
$1/250$ second, f/5.6

OVEREXPOSED BY
one stop

SPECIAL PRINTING
plum tone

LIGHTING
available late afternoon light
on a hazy day

flowing white dress from my studio wardrobe and paired it with a sheer white scarf that billows out behind the model in the ocean breeze.

setting

This image was taken near Laguna Beach, California. An old light tower and cliffs in the background create the impression of a castle off in the distance—perfect for a portrait of a princess. The model was posed standing on top of a circular stone structure on the beach.

posing

People are usually a little tired when they finish a session with me. I tend to work through a lot of poses as I decide what looks good and at what angle. I tend to experiment with a lot of things. Here, I tried the arms

up and down, at different angles, having her pretend she was a princess, etc. I always stress to my subject, however, that they shouldn't worry about doing anything wrong. There's no "wrong" in this process— it's all about working together to get to the pose that ultimately looks right.

. . . to create an image that made her look like a princess.

printing

This image was printed in a plum tone that suits the magical quality of the image.

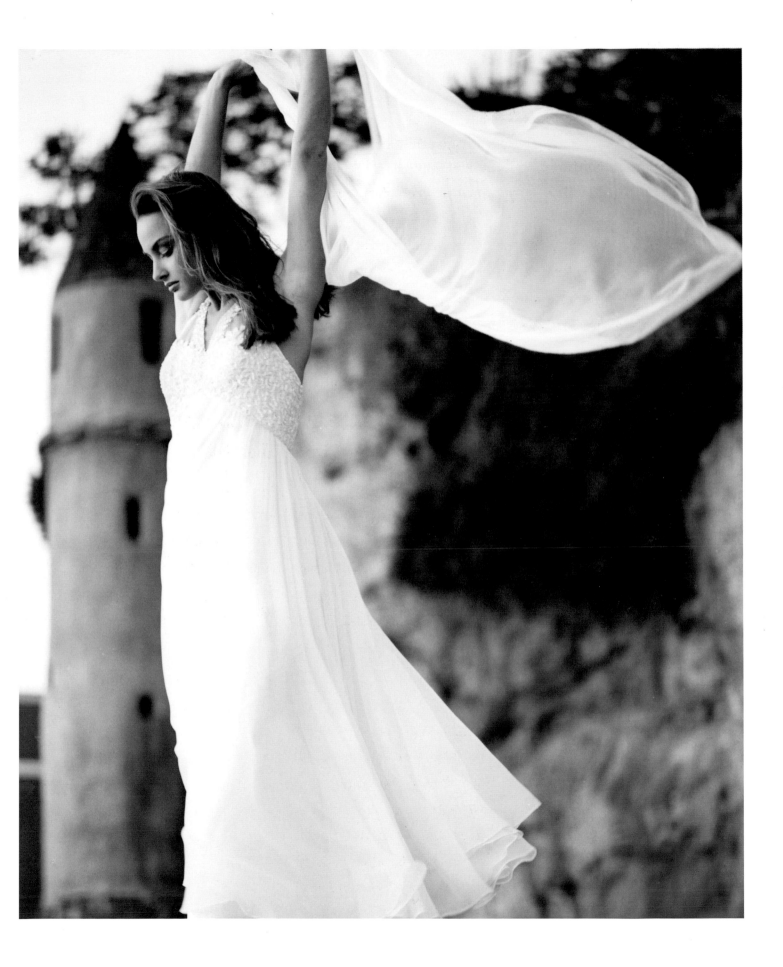

MOTHER-TO-BE

concept

I love romantic portraits with a Renaissance flavor, so I often suggest this look to my clients. Most are very receptive and excited about the idea. That's the idea used in this portrait—and what mom-to-be wouldn't want to look like a goddess?

makeup

In color photography, makeup is a lot more important than in black & white. I tailor the look of the makeup carefully to the client and the look we are going for in the image. If you are not trained to apply makeup for your clients, consider hiring a professional. You'll spend a hundred dollars, but you'll probably sell a thousand more in portraits. Makeup can make or break a portrait.

What mom-to-be wouldn't want to look like a goddess?

With this mother-to-be I wanted to create a very natural and earthy "mother goddess" look. I scattered flowers in her hair and gave it a carefree, tousled look. Her makeup compliments this with natural, earthy tones on her eyes and lips.

clothing

Since we wanted to show her pregnancy without being too revealing, the woman is wrapped in a velvet shawl. Shawls are wonderful, versatile props and I have lots of them on hand at the studio.

jewelry

My attitude toward jewelry is the same as toward clothes—keep it simple. If in doubt, I leave it out. More and more people have body piercings, and my attitude toward that more permanent adornment is a little different. I consider that part of their personal expression, so I don't have any problem with it. It's more a part of who they are than an accessory.

quick reference

CAMERA
Mamiya 645

LENS
150mm

FILTER
81C

FILM
Konica 3200

METERED AT
$1/60$ second, f/16

EXPOSED AT
$1/60$ second, f/8

OVEREXPOSED BY
two stops

LIGHTING
window light

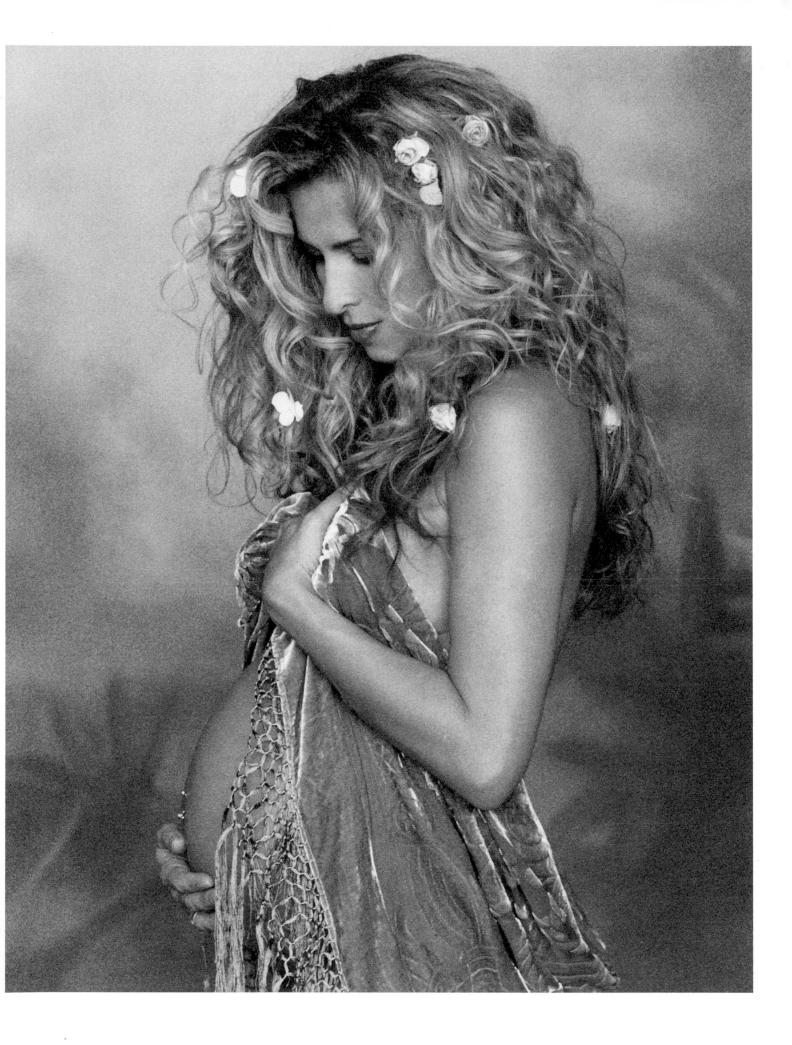

location

This image was taken at the entry gate to a canyon about twenty miles from my studio. The model is dressed in a beautiful vintage gown that works well with the aged look of the iron gate behind her.

rules

This composition is a little unusual. While a textbook would probably say to leave room for the subject to walk into, here she has room that she has moved out of. As you have seen throughout this book, I'm not really interested in rules. I think my instinct for what looks good and interesting is a better guide. That's what it's all about, after all—putting your vision on film.

If you follow all the rules, I also feel like you risk losing your spontaneity and creativity—plus your images look pretty much like everyone else's. The proof that rules don't make or break an image is simply this: my studio is always busy because people like and buy my images.

hold the sides of the dress or drop it, and to give me a variety of expressions. The final pose seen here is delicate and moody—a subdued look.

My instinct for what looks good and interesting is a better guide.

quick reference

CAMERA
Mamiya 645

LENS
150mm

FILTER
81B

FILM
Fuji NPH 400

METERED AT
$1/125$ second, f/8

EXPOSED AT
$1/125$ second, f/5.6

OVEREXPOSED BY
one stop

LIGHTING
available light reflected
by white fill card

posing

As with most of my images, we did a lot a variations on the posing. I asked the model to walk this way and that way, to

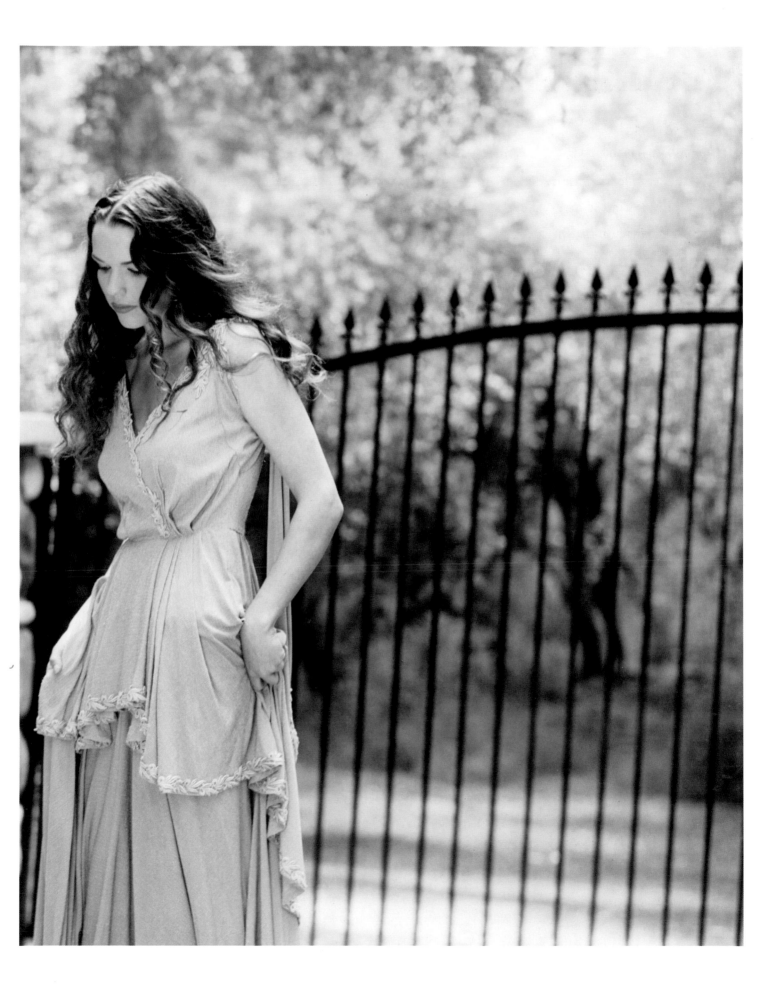

WHITE SHEETS

concept

This is one type of shot that I do all the time because it works well with almost every one of my female clients. The look is clean and simple, showing off the person rather than her clothes or props. It is also very sexy without looking like a typical boudoir or glamour image.

When I do Valentine's Day promotions, I offer a package that includes three setups. Almost invariably, the model will like something from this white sheet setup the best. Everyone seems to love the timeless quality of this look.

lighting

Using window light always gives me a nice, soft quality of light. An added bonus of this white sheet setup is that, by surrounding the model with reflective surfaces, shadows almost completely disappear, creating an incredibly smooth, flawless texture on the skin. I also overexpose these shots by two stops to lighten and clean up the skin tones even further.

hair

We call this a bedroom look. The goal is to get a look that (even though we do work hard to achieve it) looks effortless and natural—like she just rolled out of bed.

manicure

I don't do nails before the shoot, but do ask clients to come with their nails manicured. For an image like this, a very natural look works best.

Composition

The model's head is tilted

Some coaching can, of course, help to direct the process.

slightly down for a more sensual look. Because of this, her body also extends diagonally across the frame, creating an engaging composition that draws the viewer's eye from corner to corner.

For another portrait in this style, see page 82.

quick reference

CAMERA
Mamiya 645

LENS
150mm

FILM
Ilford XP2

METERED AT
$^1/_{125}$ second, f/8

EXPOSED AT
$^1/_{125}$ second, f/5.6

OVEREXPOSED BY
one stop

SPECIAL PRINTING
sepia tone

LIGHTING
window light

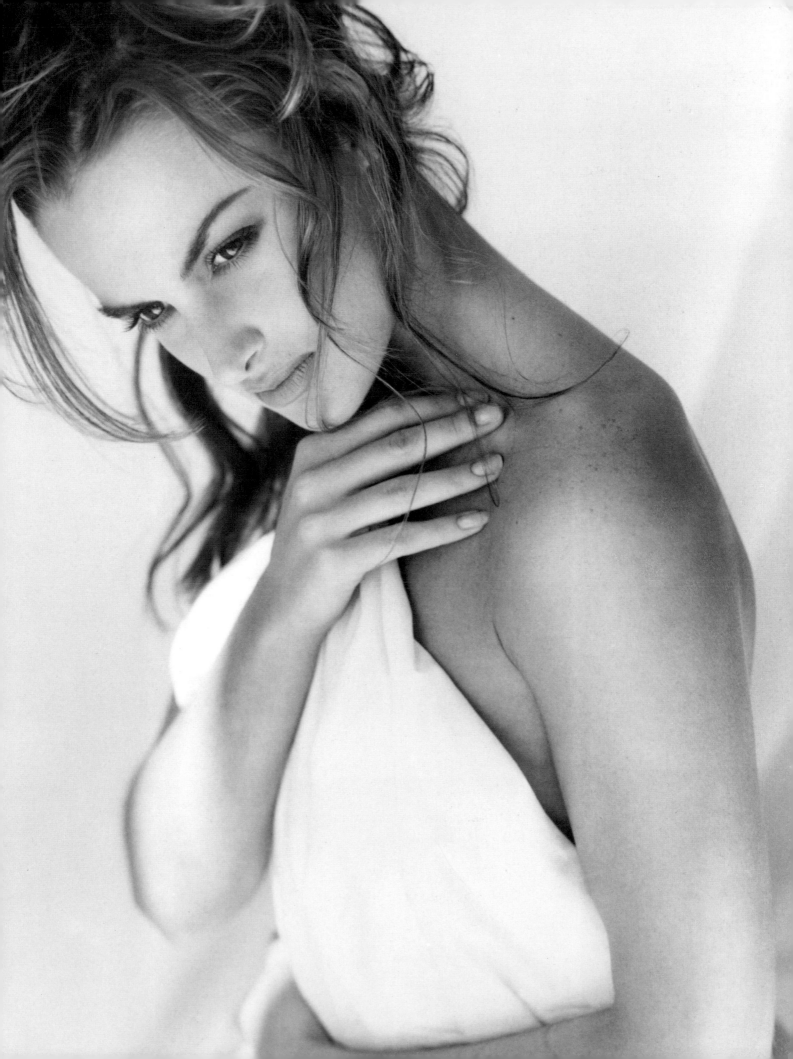

CROSS PROCESSING

Concept

It's fun when clients bring funky clothes and props to the shoot. It gives me new ideas to work with and makes their images all the more unique.

cross processing

This image was shot on Kodak EPP transparency film. The ASA of this film is 100, but my formula is to rate it at 40 ASA. In development, the film was pushed one stop by increasing the development time. This boosts the contrast and the grain in the image. The film was also cross processed by developing it in C41 chemistry instead of E6 chemistry. This creates interesting color shifts that can be unpredictable.

Lighting

The late day sun was low in the sky, so the subject was posed facing into it. This put nice, even light on her face and body. The direct light also creates

With this formula, I've had reasonably predictable results.

With this formula, I've had reasonably predictable results. As you can see it tends to make the colors very vibrant and intense. It also seems to render the skin tones in an acceptable way, making them warm and peachy.

Because there are still elements left up to chance, however, whenever I cross process images, I let the client know that they may or may not come out as expected. I also make sure to back up the images with regular film just in case the unexpected does occur.

bright highlights that suit the contrasty look of the image.

quick reference

CAMERA
Mamiya 645

LENS
150mm

FILM
Kodak EPP 100
transparency film

RATED AT
40 ASA

PROCESSING
pushed one stop,
cross processed E6 film in
C41 chemistry

LIGHTING
available late afternoon light,
in direct sunlight

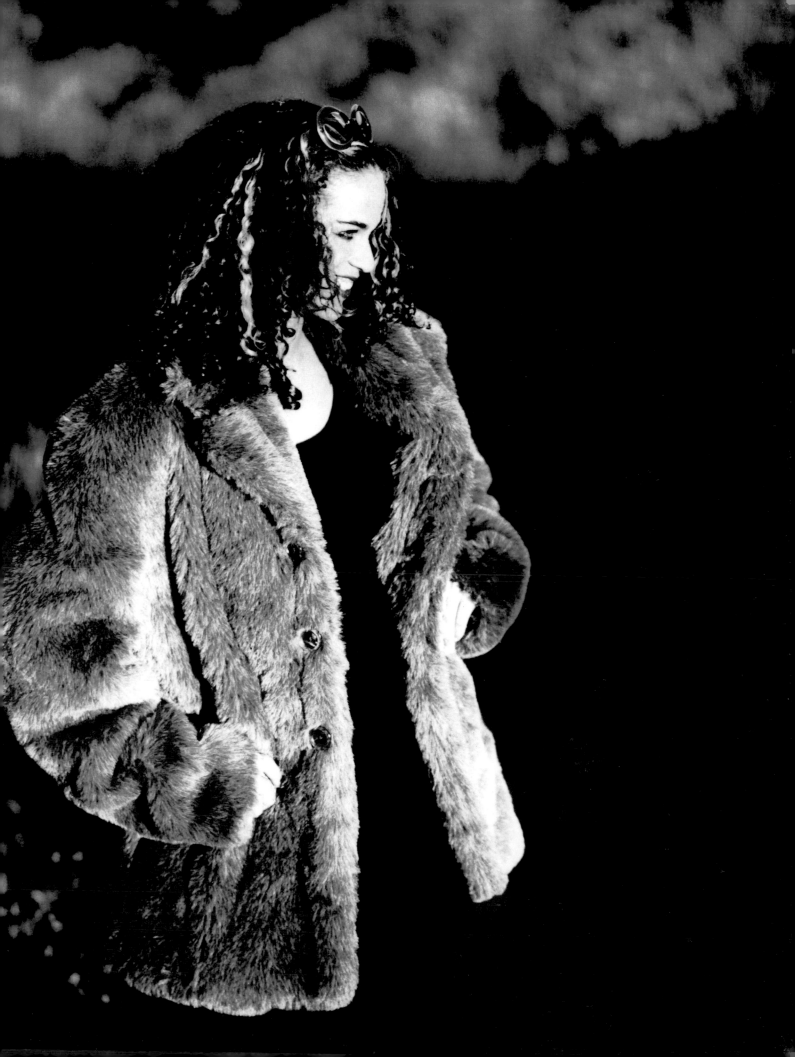

cross processing

Although the same film and processing was used to create it, if you compare this image with the one on the previous page you'll see that a totally different look was achieved.

This unpredictability is why it is important to let clients know ahead of time that it may or may not work as expected. While the unanticipated effect happens to work here, it's a very unusual look that wouldn't work with just any image.

quick reference

CAMERA
Mamiya 645

LENS
150mm

FILM
Kodak EPP 100
transparency film

RATED AT
40 ASA

PROCESSING
pushed one stop,
cross processed E6 film in
C41 chemistry

LIGHTING
available light in open shade

In the setting where the image was taken, the foliage was yellow, but in the final image almost everything in the frame

Almost everything in the frame recorded as very yellow.

recorded as intensely yellow. I've actually tried to recreate this image but have never gotten the same results.

location scouting

Wherever I go, I always keep my eyes open for unique shooting area to use in my portraits. This is a key factor in providing unique and varied images to my clients. As it happens, this one is right across the street from my studio. This tree turns bright yellow for about two weeks out of the year.

clothing

When the subject brought this dress, which was pale yellow, I knew that this yellow foliage would provide the perfect setting for the portrait.

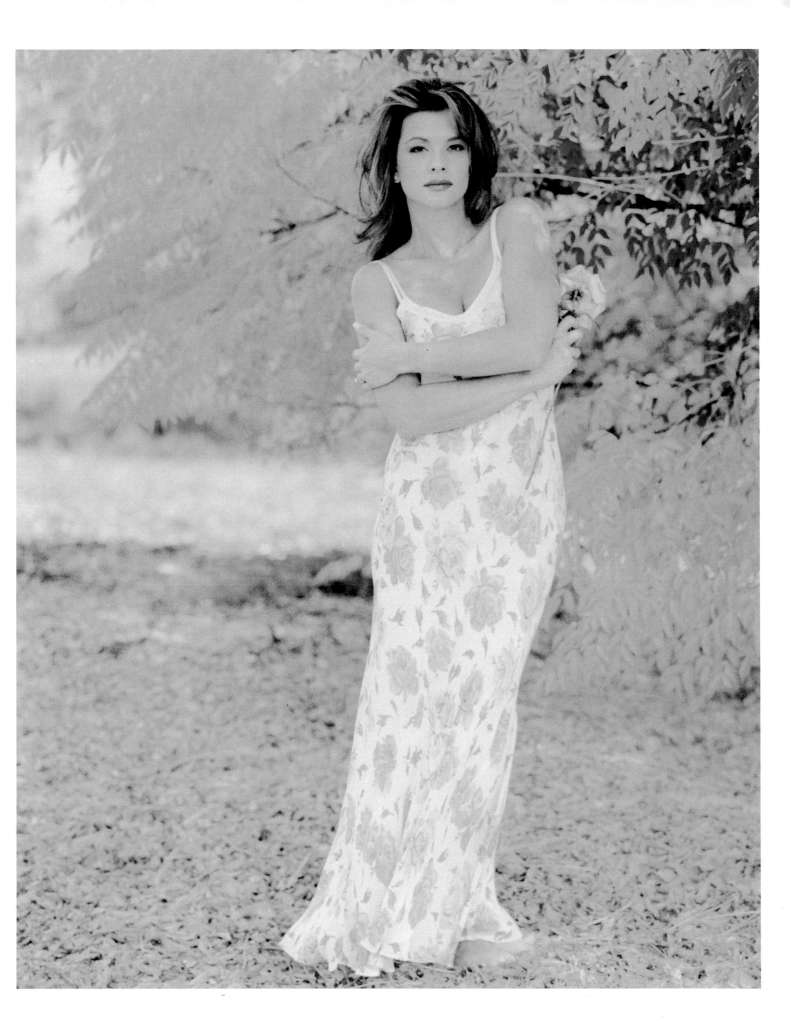

cross processing

This image employs the second formula for cross processing that I have found to work reasonably well. The image was shot on Fuji RHP 400 film (rated at ASA 400). A warming filter was also used on the shot. The film was then pushed two stops by increasing its development time. This increases the contrast and grain. It was also cross processed by developing this E6 film in C41 chemistry. Again, this produces color shifts in the film that can yield unique and interesting results in a portrait.

quick reference

CAMERA
Mamiya 645

LENS
150mm

FILTER
81C

FILM
Fuji RHP 400

RATED AT
400 ASA

PROCESSING
pushed two stops,
cross processed E6 film
in C41 chemistry

LIGHTING
direct window light

concept

This client was a mature woman and a dramatic artist. She wanted portraits that were dramatic and very different.

colors

The colors in this portrait help create the desired dramatic effect. From the deep blues and greens in the feathers on her hat, to the plum tone of her shirt and the rich red on her lips, the photograph displays a full range of jewel tones. All of these help to set off the woman's intense blue eyes.

makeup

Again, this client was a very dramatic woman, so I chose makeup that was equally intense. With jet black on her eyes and deep red on her lips, these features jump out strongly from her porcelain skin.

Cross processing the photograph emphasized these features . . .

concept

Cross processing the photograph further emphasized these features by increasing the contrast of the image.

exposure

Normally, I overexpose my image one or two stops to clean up the skin tones. When cross processing my film, this isn't necessary. Because the film is pushed one or two stops in development, the same effect is achieved.

lighting

The subject was posed facing the window that is the light source for the portrait. This creates a smooth, even texture on her skin.

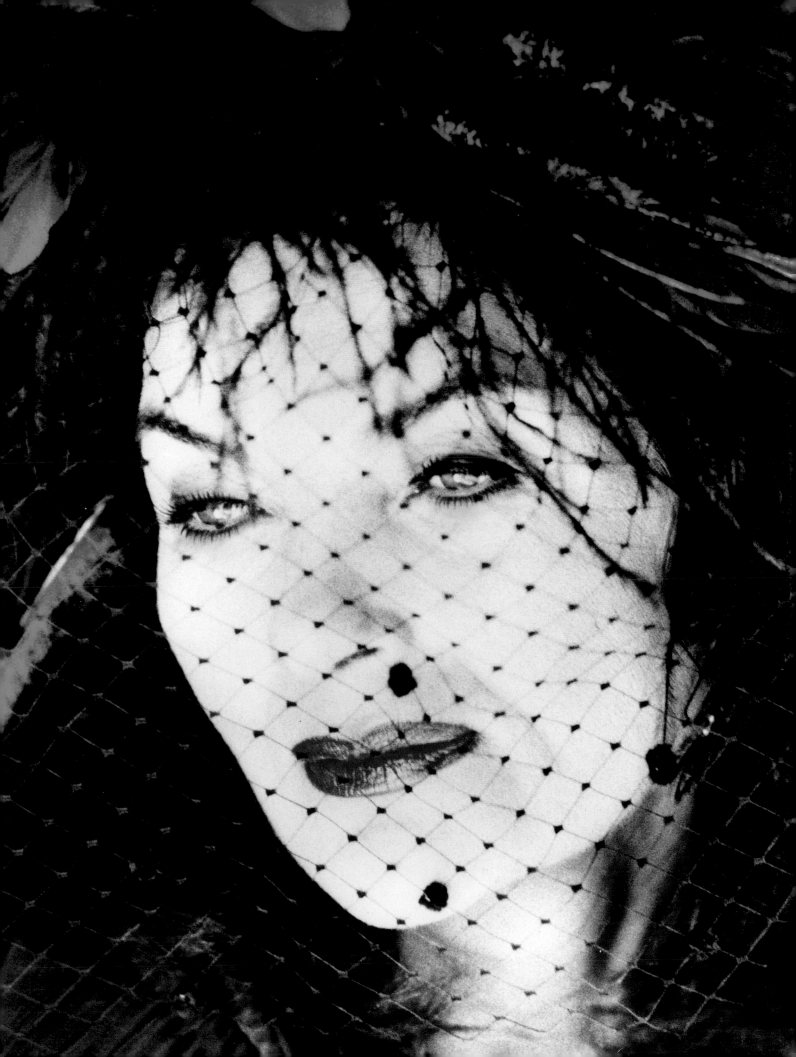

CANDLELIGHT

concept

I wanted to create an image with a Gothic, old-world feel, so I created a richly textured set full of textiles and candles. Behind the model is a painted canvas with a warm-toned foliage pattern. Beneath her and running up the wall is a large piece of burgundy velvet. A cushion was placed under the velvet to provide a base for posing the model. Because she was really into the concept of the shoot, the subject brought the candelabras from her own home, as well as the richly colored grapes that are scattered around her. The tawny fringed shawl that is draped around her is one of my own props from the studio. As you can see, this elaborate set was truly a collaborative effort!

lighting and posing

The main light for the image came from a strip light positioned directly over the model. This ran the length of her body. Keeping her in this band of light meant we were a little more limited than normal in posing options. Still, the final pose is both flattering and well-suited to the scene.

A relatively long exposure of one second was used for the shot. This was done in order to pick up more of the light from the candles—important for setting the desired mood.

quick reference

CAMERA
Mamiya 645

LENS
150mm

FILTER
81C

FILM
Kodak VC 400

EXPOSED AT
strobe metered at $\frac{1}{60}$ second, f/4, exposure made at one second, f/4, to pick up light from the candles

OVEREXPOSED BY
one stop

LIGHTING
candles, large strip light placed directly over model

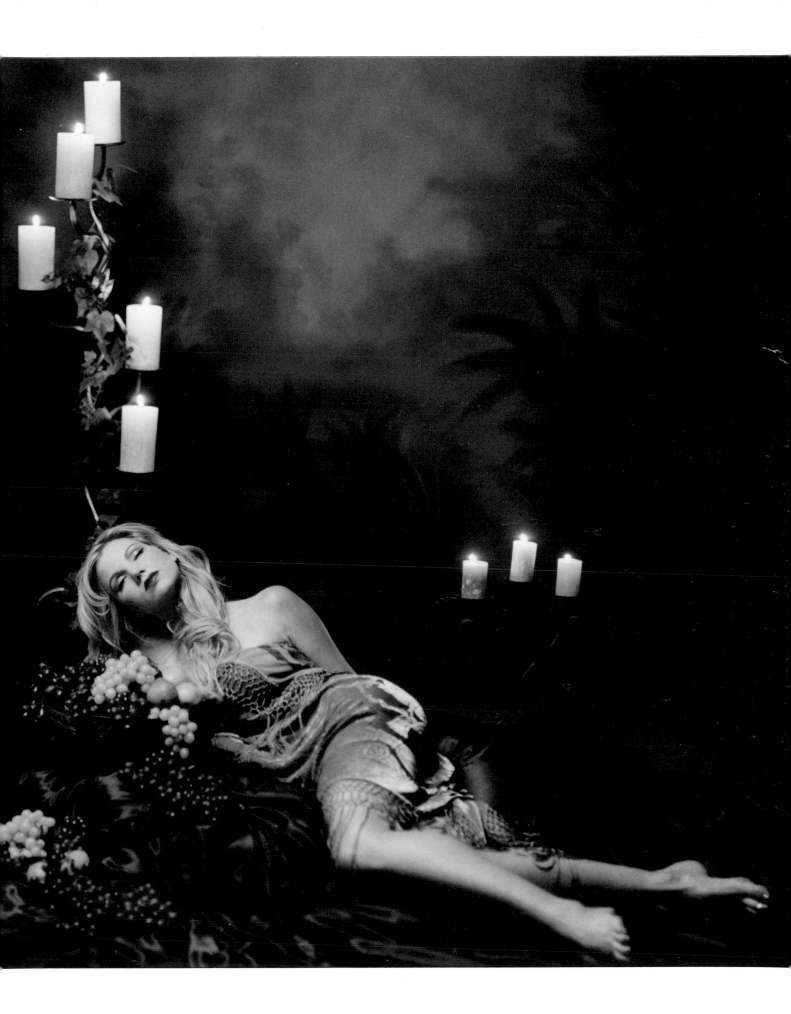

TRIED AND TRUE

concept

This is a variation on the white sheet setup that was discussed in greater detail on page 72. It's a shot that I have success with over and over again.

One reason this shot is so versatile it that it works with women of any body type. Since the sheet can be moved around easily, you can simply reveal what she wants to show and cover anything she doesn't want seen. It's also a great way to create a nude image where

nothing shows—here, the model is just as covered as she would be in a strapless evening gown.

set

The model is posed laying down on a white backdrop and facing a large window. She is wrapped in a white flannel sheet. I prefer to use flannel sheets for images like this because they are much softer looking than a regular cotton sheet.

lighting

The window light in this image produces nice soft light. The reflective surfaces around the model make the shadows very light, creating a very even texture on the skin. The portrait is overexposed by two stops to lighten and clean up the skin tones.

quick reference

CAMERA
Mamiya 645

LENS
150mm

FILM
Ilford XP2

METERED AT
$^1\!/_{125}$ second, f/8

EXPOSED AT
$^1\!/_{125}$ second, f/4

OVEREXPOSED BY
two stops

LIGHTING
window light

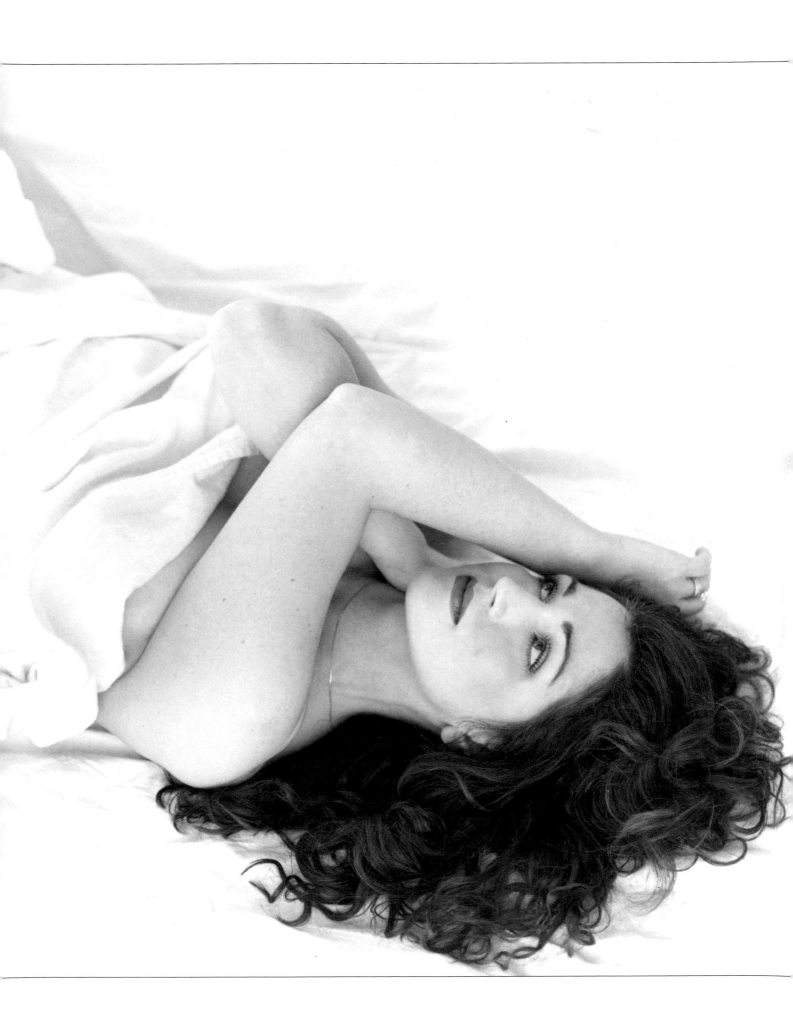

PERSONALITY

subject

This is a portrait of my mom. When I took this portrait for her birthday a few years ago, I wanted to create an image that captured her happy and relaxed personality in a very natural way.

lighting

The light from this portrait comes from a window, but the subject is actually posed in what amounts to an area of open shade. In other words, she was posed far enough from the window that light from it wasn't falling directly on her. The direct light fell off just in front of the place where she was posed.

clothing selection

A white cotton shirt with jeans is such a classic look—it's a great choice for portraits because it never looks dated. With the black background here, the white shirt and lighter jeans really help make the subject pop out in the image.

posing

The subject was seated on the back edge of a stool, basically with one leg over the top. Her hands where then placed close to each other on the open edge of the stool in front of her. Again, I do lots of poses with each subject, so this was just one of several poses we tried.

styling

To keep that clean and natural look, the subject's hair looks a little tousled, but still groomed and stylish. Her makeup is a little heavier than for everyday wear, but is muted by the black & white so it looks very simple and understated.

I wanted to capture her happy and relaxed personality . . .

printing

Overexposing the image one stop left the white shirt and skin tones bright and clean. A traditional, untoned print maintains this clean, natural look.

quick reference

CAMERA
Mamiya 645

LENS
150mm

FILM
Ilford XP2

METERED AT
$1/250$ second, f/8

EXPOSED AT
$1/125$ second, f/8

OVEREXPOSED BY
one stop

LIGHTING
window light

M·O·M W·I·T·H F·L·O·W·E·R

subject

This is another portrait of my mom. If you compare it to the one on the previous page, you'll see how much difference a few changes can make in the character of a portrait. This image, taken during the same session as the previous one, has a more fanciful flair. This giant flower was selected as a prop because my mom is a florist.

lighting

As in the previous portrait, the subject was posed looking toward the window, right at the point where the direct light from the window ended and the shade started.

clothing selection

The white cotton shirt from the previous image was exchanged for a black tank top here. This is another classic look, and one that also helped the flower stand out better than it would have against a white shirt.

posing

The subject was seated and leaning forward with the flower held in front of her. Both she and the flower are facing directly into the camera. This creates a very emphatic, symmetrical look.

styling

Still going for that clean and natural look, the subject's hair was simply swept up loosely, with a few strands allowed to escape for a softer, more relaxed look.

printing

The image was also overexposed by one stop to make the skin tones clear and light, and the flower bright white.

This creates a very emphatic, symmetrical look.

quick reference

CAMERA
Mamiya 645

LENS
150mm

FILM
Ilford XP2

METERED AT
$1/125$ second, f/8

EXPOSED AT
$1/125$ second, f/5.6

OVEREXPOSED BY
one stop

LIGHTING
window light

POSING

concept

This client wanted pictures that looked very, very natural. We did several images at the beach using natural light only. She also wanted to be very sexy. Here, we see a shot that looks like a nude, but with nothing showing.

posing

My background in modeling really comes in handy when it comes to posing. Because of this experience, I have a pretty good idea about what positions make the body look best. I usually just act these out myself so that my subjects, who usually

I offer a lot of direction to my subject throughout the session.

aren't professional models, can simply imitate what I'm doing.

I offer a lot of direction to my subject throughout the session and always try a variety of different poses with each client—to find out what works best with that individual. Maybe three out of ten poses don't look right, so I don't shoot those. This works your clients a little harder, but I think it's worth it to find the poses that really flatter them the most.

lighting

This image was actually created just inside a cave on the beach. This creates basically the same situation as shooting with window light. The subject was laying the sand, and I had her roll onto her back. I then asked her to lift her arms up over her head. The fact that her arms were covered in sand makes the image look all the more earthy.

printing

The sepia tone of the image coordinates with the sand in the image and brings the model's skin tones to life.

quick reference

CAMERA
Mamiya 645

LENS
150mm

FILM
Ilford XP2

METERED AT
$^1/_{125}$ second, f/5.6

EXPOSED AT
$^1/_{125}$ second, f/3.5

OVEREXPOSED BY
$1^1/_2$ stop

SPECIAL PRINTING
sepia tone

LIGHTING
available light in open shade

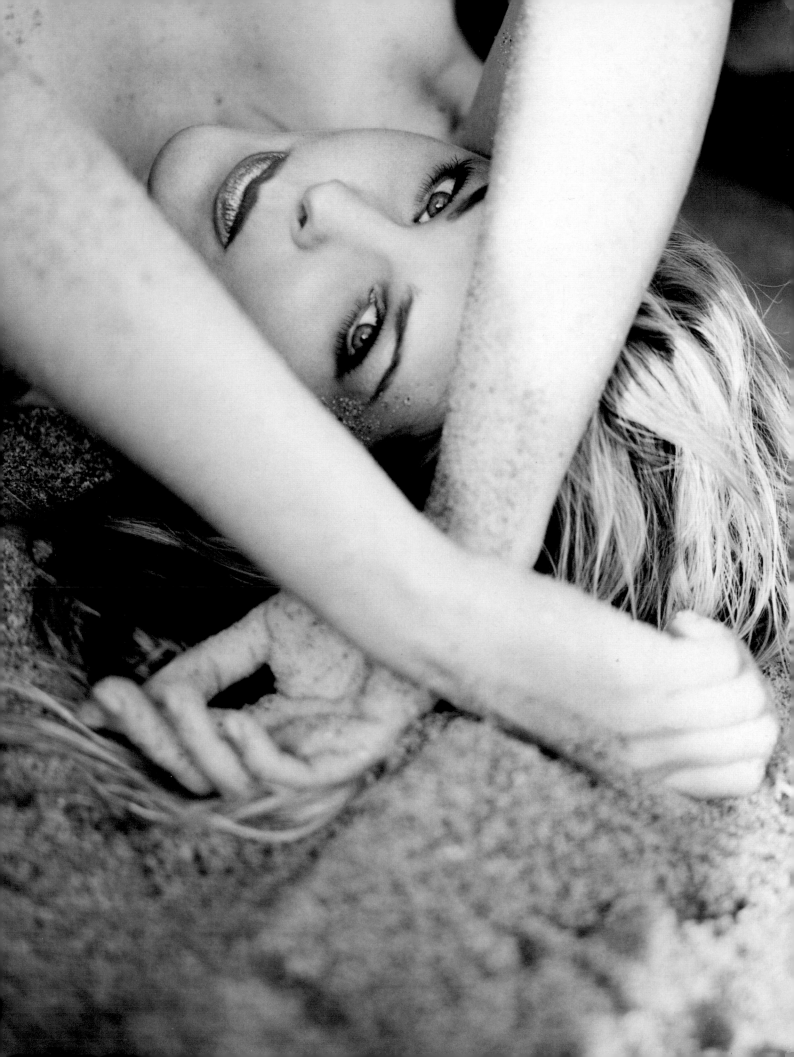

set

The model was posed laying down on a dark piece of velvet, which also runs up behind her and forms the background of the image.

clothing and props

The client brought this eye-catching outfit with her for the shoot. We added the huge red flower to make it an even more dramatic look—again, going for something like the edgy style used in the advertising for fashionable women's clothing lines like Bebe®.

camera angle

As noted, the model was posed laying on her back on a piece of velvet. Her legs were then elevated to complete the curvy diagonal of her body through the frame. I then shot from a high angle, looking down onto the subject.

would. In my dream studio, I'd have big windows facing every direction so I'd always have good window light to work with. The effect of natural light on the skin and the way it seems to make eyes look bigger and brighter makes it a big favorite with my clients as well.

In my dream studio, I'd have windows facing every direction . . .

quick reference

CAMERA
Mamiya 645

LENS
150mm

FILTER
81C

FILM
Konica 3200

METERED AT
$\frac{1}{125}$ second, f/11

EXPOSED AT
$\frac{1}{125}$ second, f/5.6

OVEREXPOSED BY
two stops

LIGHTING
window light

lighting

It may look complicated, but the lighting for this shot was all from a single window. The model was posed with her face turned toward the window, and positioned just out of the direct light from it (in the area of open shade just beyond the direct light).

As I've said time and again, if I could shoot only natural light, I

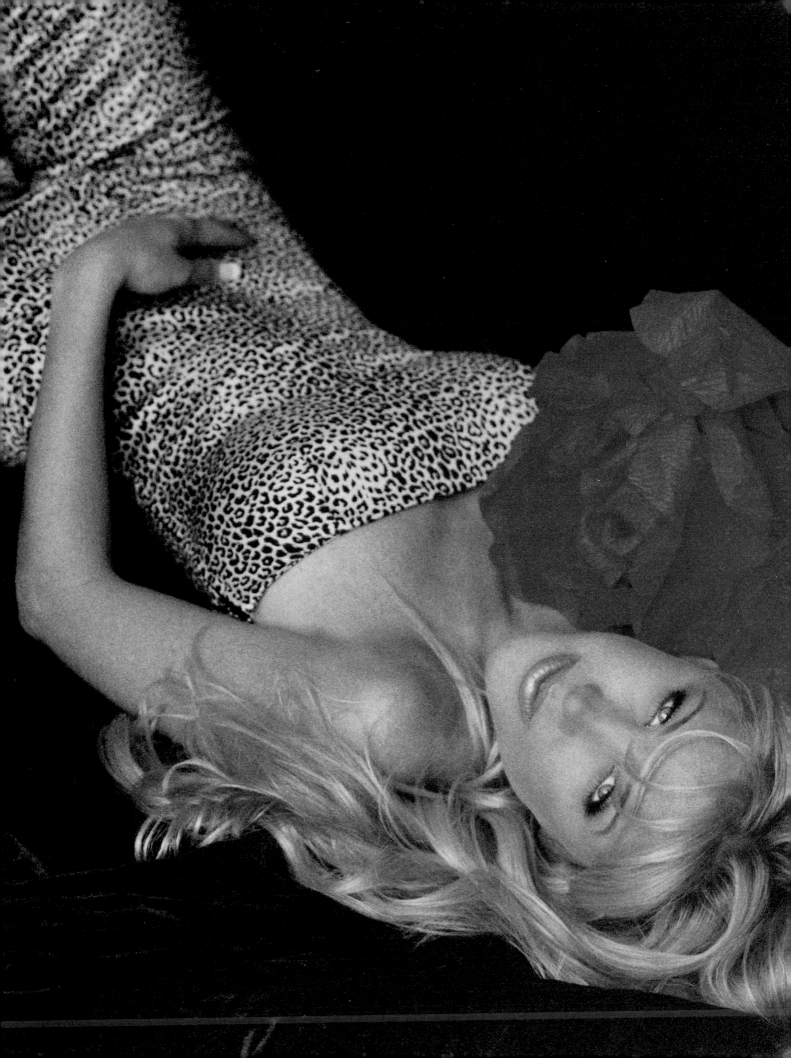

LIGHT RATIO

subject

The subject of this photo is a professional model who does a shoot every year to update her portfolio and get new images for her website.

lighting

This image was taken in the late afternoon in a local park. The sun was quite low in the sky and backlit the subject. This backlighting made it important to watch the skin tones on the

quick reference

CAMERA
Mamiya 645

LENS
150mm

FILM
Ilford XP2

METERED AT
$1/125$ second, f/11

EXPOSED AT
$1/125$ second, f/8

OVEREXPOSED BY
one stop

SPECIAL PRINTING
sepia tone

LIGHTING
late afternoon sun with white card used for fill

shadow side so they wouldn't reproduce too dark.

The image was metered for the shadow side of the model's face. To decrease the light ratio (the difference in exposure between highlight and shadow areas), a fill card was placed facing the shaded side of the

model. This card increased the amount of light falling on this area by one full stop. As a result, the shadows are more open and the skin has a nice tone.

exposure

The tones were also brightened throughout the image by over-exposing by one stop.

concept

The look we wanted was natural and relaxed. We were going for a look that was somewhat

earthy, so her hair was very loosely braided for something that hints at an all-American farm girl look. Including some of the background also helped create this natural flavor.

printing

Sepia toning was also used to create an earthy mood.

The sun was quite low in the sky and backlit the subject.

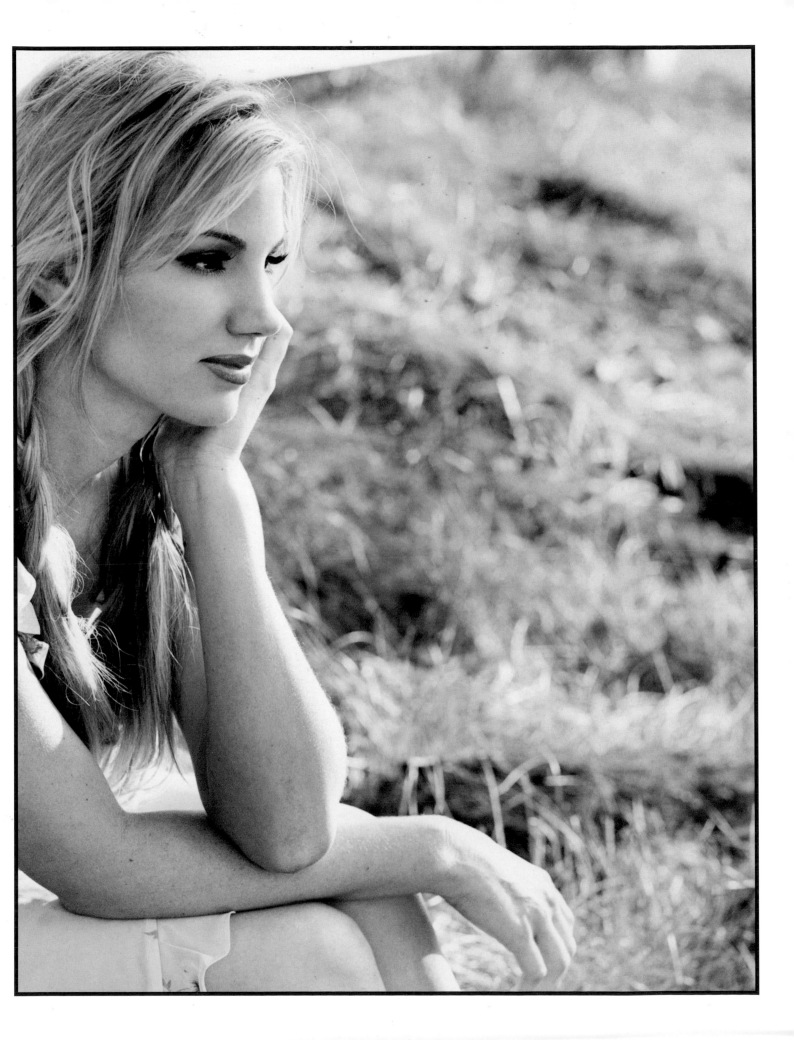

FOR HER HUSBAND

lighting

Are you sold on window lighting, yet? Here's another example of a portrait made using only window light to illuminate the subject. As you've seen time and again in this book, the effect achieved is incredibly flattering. Because subjects can move around freely within it, it also permits you to work more freely for better posing without constantly readjusting your lights—a win/win situation for both you and the client!

quick reference

CAMERA
Mamiya 645

LENS
150mm

FILTER
81C

FILM
Kodak NPC 400

METERED AT
$^1/_{125}$ second, f/8

EXPOSED AT
$^1/_{125}$ second, f/4

OVEREXPOSED BY
two stops

LIGHTING
window light

concept

The client wanted to have a portrait for her husband. She

She was looking for something that was very classy.

was looking for something that was very classy.

set

A piece of black velvet was used in the background. This was kept a few feet back from the subject so that it would go completely black. On the floor is a leopard print throw that the client provided for the shoot.

makeup and hair

The makeup is a little heavier than normal on the eyes to match the more dramatic character of the leopard print. The hair is soft and natural.

posing

While the setup I chose was basically the same as I would use for a shot with the subject

laying down, we wanted a little more of a classy look for this portrait, so her body is more upright. Supported on her arms and with her knee pulled up, the pose in this portrait is both dramatic and flattering.

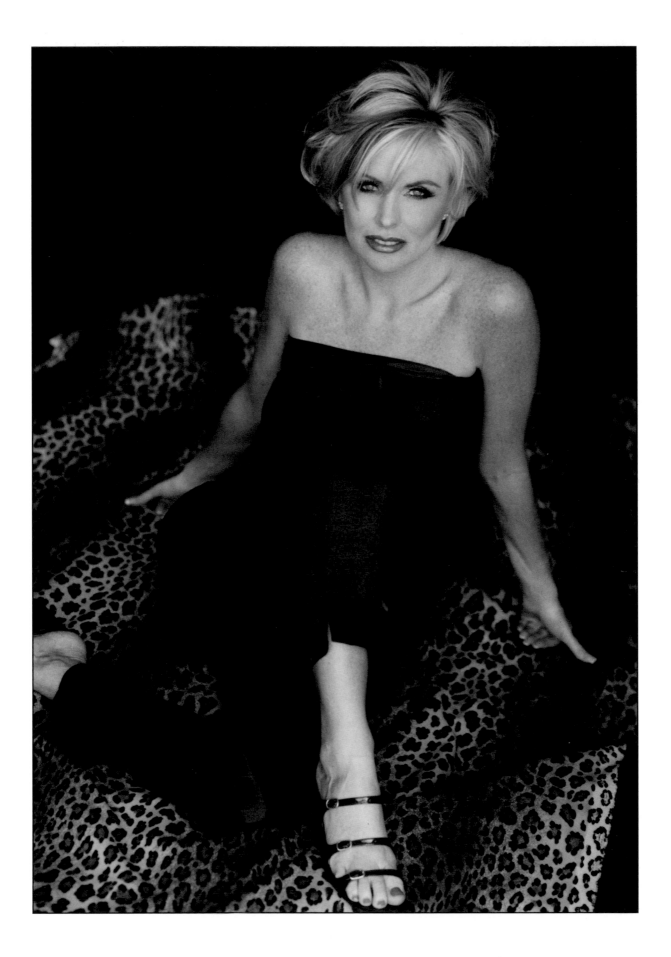

SUNSET PORTRAIT

concept

I shot this image for use on the cover of one of my studio brochures. I wanted to create a portrait with the feel of a Maxfield Parrish nighttime painting. I paired this idea with a dramatic Renaissance feel to create the image you see here.

setting

The image was created in my backyard. In the distance you can see the natural sunset in the mountains. This is

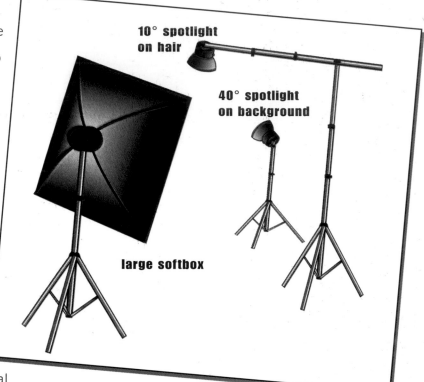

10° spotlight on hair

40° spotlight on background

large softbox

CAMERA
Mamiya 645

LENS
150mm

FILM
Kodak VC 400

EXPOSED AT
½ second, f/4 (long exposure
to pick up setting sun)

LIGHTING
medium softbox with warming
filter high and to left (main
light), 10° spot as hair light,
40° spot with blue gel on
background, natural sunset
(see diagram)

the backdrop for the image. Around the model are rose bushes. To make them seem full of blooms, we picked roses from other bushes and worked them into the area around the model.

lighting

A small softbox was fitted with a warm gel and placed high and to the left of the model, creating the warm orange tones on her skin. A spotlight placed above the model adds highlights to her hair. The final ingredient in the lighting setup was a spotlight fitted with a blue gel that was directed at the background.

makeup and hair

The model was styled for a warm, romantic look. Her hair is in loose curls around her shoulders, and her lips and eyes (both made up in warm colors) are dark and dramatic.

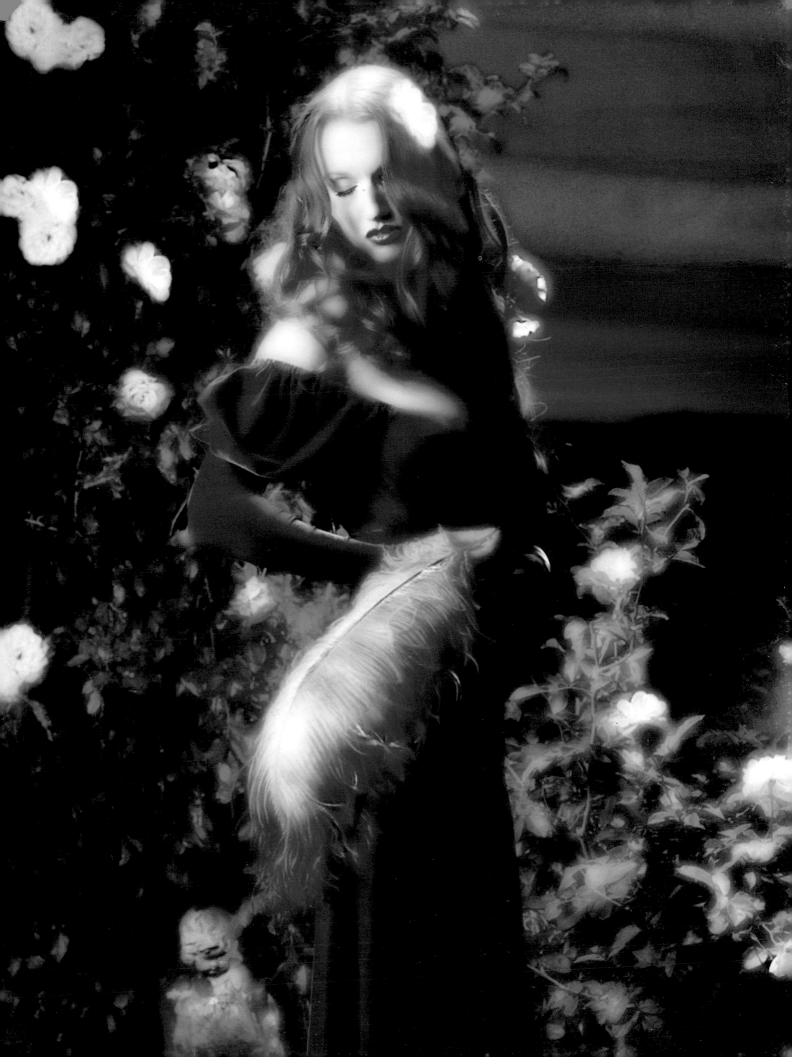

SECTION

4

FAMILIES

scheduling

When working outdoors with natural light, you have much less control over your shooting environment. Since problems are bound to arise occasionally, I ask clients ahead of time if they are open to doing something in the studio if the weather presents a problem. Usually, they have no problem with that.

If I know that an environmental portrait is very important to the client, I'll usually give them one free cancellation in the event of bad weather. If problems also prohibit a location shoot for the second session, then we move into the studio. As I've noted, I like to spend a lot of time with my clients. Therefore, I can only do two or three sessions a day. That makes it very important for me to avoid—as much as possible—having to reschedule my sessions.

quick reference

CAMERA
Mamiya 645

LENS
150mm

FILM
Ilford XP2

METERED AT
$^1\!/_{125}$ second, f/11

EXPOSED AT
$^1\!/_{125}$ second, f/8

OVEREXPOSED BY
one stop

SPECIAL PRINTING
sepia tone

LIGHTING
sun filtered through white silk

To compensate for this, I positioned a large round silk diffusion screen to the right of the father. This softened the light, breaking up the harsh shadows without creating an effect that looked unnatural.

This softened the light, breaking up the harsh shadows . . .

lighting

The hours just after sunrise and just before sunset yield the best light for outdoor portraits. Scheduling sunset portraits usually fits both my clients' and my own schedules better than shooting at the crack of dawn. In this case, we were working about an hour and a half before sunset and the sun was still a little too bright.

posing

I try to build a unique pose for each subject or group—I don't have a set list of poses I use. Here, I got the dad down on one knee and had the son sit on his other knee. The daughter was then seated on the ground in front of them. Once I have the group in a basic arrangement, I let them play around with it and give them guidance and suggestions on what looks the best.

printing

The sepia tone of the image gives it a sandy, beach-like quality that suits the portrait.

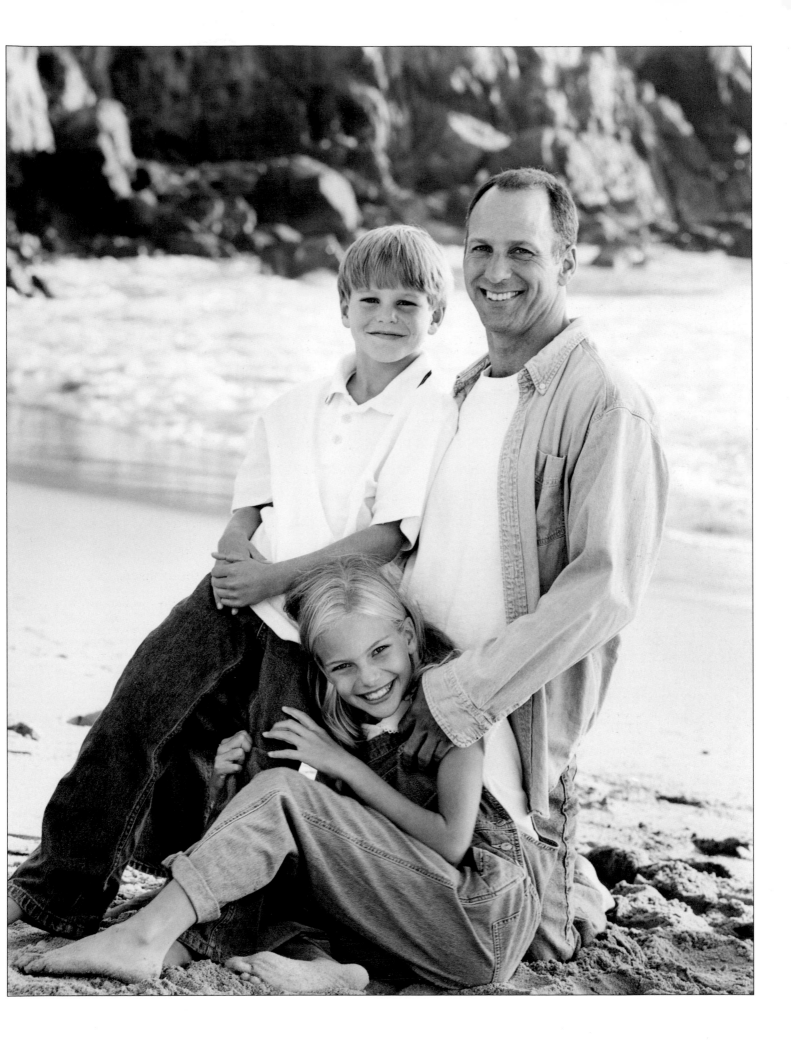

CANDIDS

environmentals

Being able to shoot beach portraits is one of the great benefits of living on the coast. Wherever you live, though, you'll probably identify a few great locations you'll use over and over again.

lighting

This couple on the beach was backlit. It was late in the day (about an hour before sunset), so the sun was low in the sky.

quick reference

CAMERA
Mamiya 645

LENS
150mm

FILM
Ilford XP2

METERED AT
$1/125$ second, f/8

EXPOSED AT
$1/125$ second, f/5.6

OVEREXPOSED BY
one stop

SPECIAL PRINTING
sepia toned

LIGHTING
reflected light
metered for shadow area

Specifically, it was behind and to the right of the man.

Because of this backlit situation, I metered for the area of the subjects' skin that was in shadow. I then placed a reflector to bounce fill light onto the

I observed them and shot the action as it unfolded.

shadow side of the couple. This, combined with overexposing the image by one stop, ensured that their skin tones would not be too dark in the final image.

candids

To capture candid images like this, you need to shoot a lot of film. I asked the couple for a playful look, and had them rolling in the sand, hugging, etc. I observed them and shot the action as it unfolded.

clothing selection

The couple wanted a vintage look for their image. The cloth-

ing selection isn't perfect for a period piece, but we definitely made it work.

printing

The sepia toning of this image was selected because it suggested the true color of the beach, and also because it added a little bit more of a vintage flavor to the image.

UPSIDE DOWN

angles

You'll undoubtedly notice that there are a lot of upside-down portraits in this book. This is something you don't usually find a lot of, but you can see here how well they can really work. Why do I do them so often? The answer is simple: my clients like them because they are different. This kind of portrait doesn't look like the portraits hanging on all of the friends' walls. The look is con-

temporary and unusual. Again, it's a more magazine-style look.

concept

This mom wanted a portrait that was natural, warm and snuggly. This image was created in my backyard. The mom and her two kids simply laid on a futon with a white mat and a white sheet. A little area of

grass was kept in the edge of the frame to better show the outdoor setting.

printing

As you can see, the image works well in either black & white (below) for a very clean look, or in sepia (opposite page) for a warmer feel.

quick reference

CAMERA
Mamiya 645

LENS
110mm

FILM
Ilford XP2

METERED AT
$1/125$ second, f/11

EXPOSED AT
$1/125$ second, f/8

OVEREXPOSED BY
one stop

SPECIAL PRINTING
sepia tone

LIGHTING
available light
through white silk

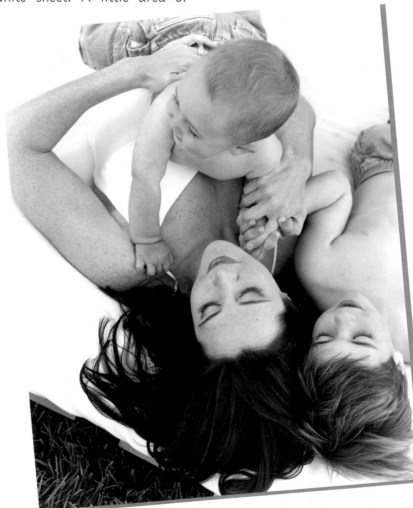

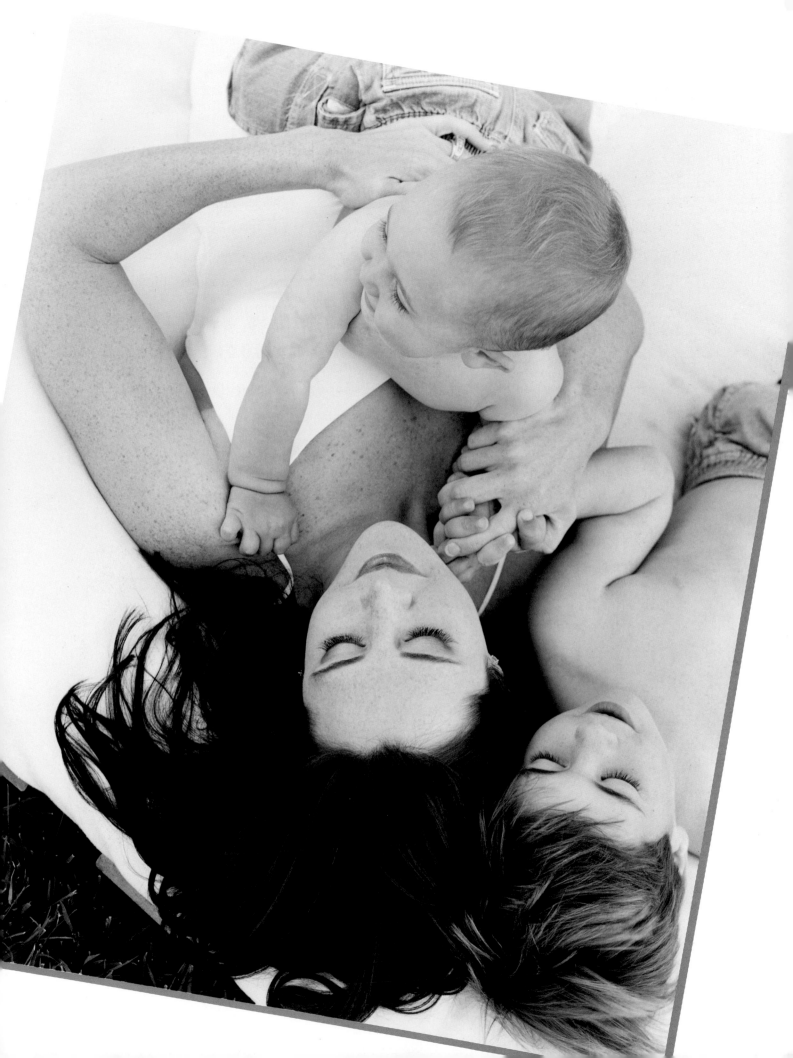

clothing selection

For a contemporary, uncluttered look, I advise clients coming in for family portraits to stick to three colors or less (preferably less) and to keep the clothes simple. I also ask them to bring more than one outfit, so we have a backup in case their first choice isn't right. As you can see in this portrait, simple black clothes in classic styles yield a portrait where the viewers' attention is drawn to the subjects' faces and emotions—not to what they are wearing.

Most people don't realize that the wrong clothes can ruin a

Clothing selection is something I stress at all of my consultations.

session, so the importance of clothing selection is something I stress emphatically at all of my consultations. After all, having to reshoot is costly for the client, and not a great use of my own time.

posing

The dad was posed first, standing in the back. The mom was seated on a stool. Then the kids were arranged around them. Everyone has their arms around each other, showing the emotional relationship between the family members.

While the posing is a little more formal than in most of my por-

traits, you'll notice that the little boy is giving a thumbs up! This certainly wasn't planned, but it's one of the things the family loved about the image— that gesture gives the portrait something unique and show's the little boy's personality.

location

We knew we wanted to do the family's portrait at a park that is located near my studio. The day of the session, I simply drove around and looked for spots that looked good that day. On this overcast day, a couple of hours before sunset, the light in this area was very soft and came slightly from the right.

quick reference

CAMERA
Mamiya 645

LENS
110mm

FILM
Ilford XP2

METERED AT
$1/125$ second, f/11

EXPOSED AT
$1/125$ second, f/8

OVEREXPOSED BY
one stop

SPECIAL PRINTING
sepia tone

LIGHTING
available light on overcast day
(sun a little to the right)

SNUGGLING MOM AND BABY

prop

Futons are great, very portable props to have on hand. Since they fold up, they are easy to store. Futons also provide an excellent, comfortable foundation for poses where the subject is laying down.

The mats can be covered with any type or color of fabric to create the look you want. You can also leave parts of the natural wood frame showing for an earthy look.

quick reference

CAMERA
Mamiya 645

LENS
150mm

FILTER
81C

FILM
Konica 3200

METERED AT
$1/1000$ second, f/8

EXPOSED AT
$1/125$ second, f/8

OVEREXPOSED BY
three stops

LIGHTING
available light at sunset

clothing

With poses where the subjects are laying down, keep clothes very simple as they will tend to bunch up in ways that don't look good.

This is especially true with kids, who tend to get lost in clothes anyway. For little kids, shirtless is the way to go. Showing their soft skin and tiny bodies creates a warm and cuddly image.

Here, the baby is wearing little white bloomers (which barely show) and the mom is covered with a white chenille blanket.

posing

The mom and baby are snuggled up together cheek to cheek, with mom holding the baby's hand in her own.

film selection

For this shot, I chose Konica 3200 film (which has since been discontinued) because I wanted to see a nice grainy structure in the image. The result is a look that is a little more dreamlike, and a bit painterly.

Mom and baby are snuggled up together cheek to cheek . . .

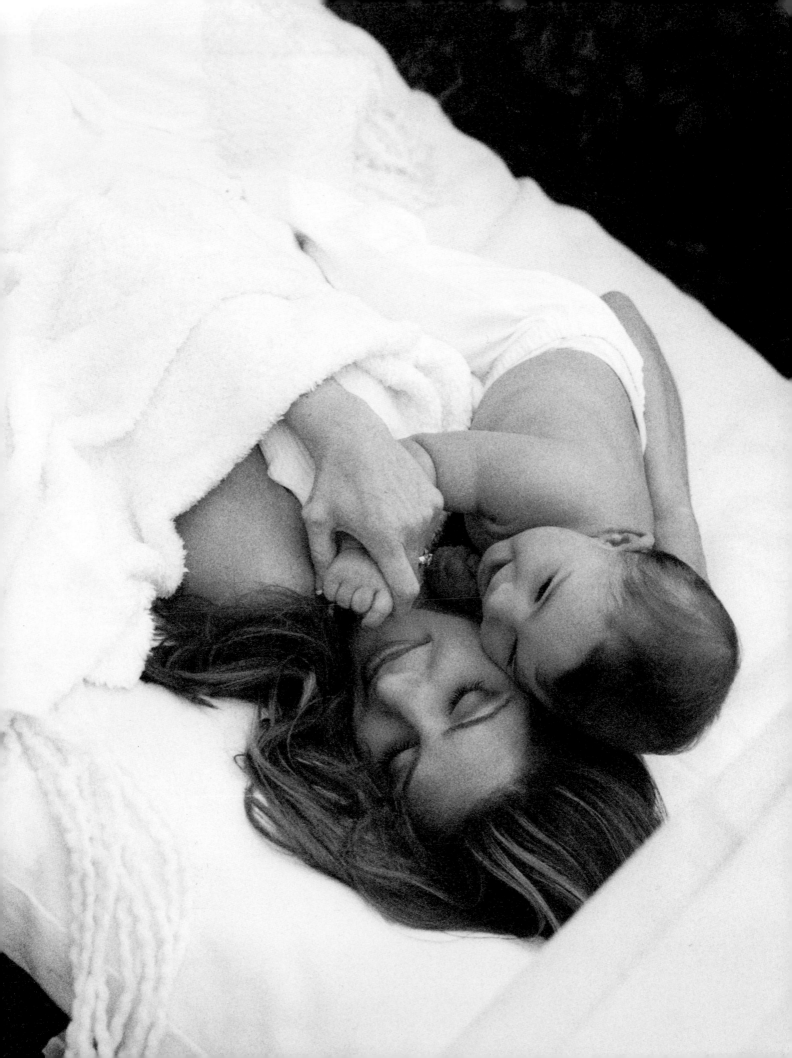

HAMMOCK

setting

This is my best friend and her five children. They all piled into a hammock for the shot. The sun was dropping fast so we took the shot quickly—hurrying everyone over and into the hammock.

film selection

Choosing a high speed film was very important for this shot. First, it was late in the day with the light getting a little low. Second, I needed a small aper-

quick reference

CAMERA
Mamiya 645

LENS
110mm

FILTER
81C

FILM
Konica 3200

METERED AT
$1/125$ second, f/16

EXPOSED AT
$1/125$ second, f/8

OVEREXPOSED BY
two stops

LIGHTING
available late afternoon light

ture in order to keep everyone's face in focus. Finally, because the subjects were posed in a hammock, there was bound to be a certain amount of movement. This made it necessary to use a faster shutter speed to freeze the action for a sharp portrait.

camera angle

As with most "laying down" shots, a high camera angle is needed to get the right perspective. In this case, I shot this portrait looking down from a high ladder.

clothing selection

The boys went shirtless and the girls and mom wore sleeveless tops, so the focus of the portrait remains on the family's faces. A white blanket covers up what would be visible of the clothes, and is an appropriate prop for the image.

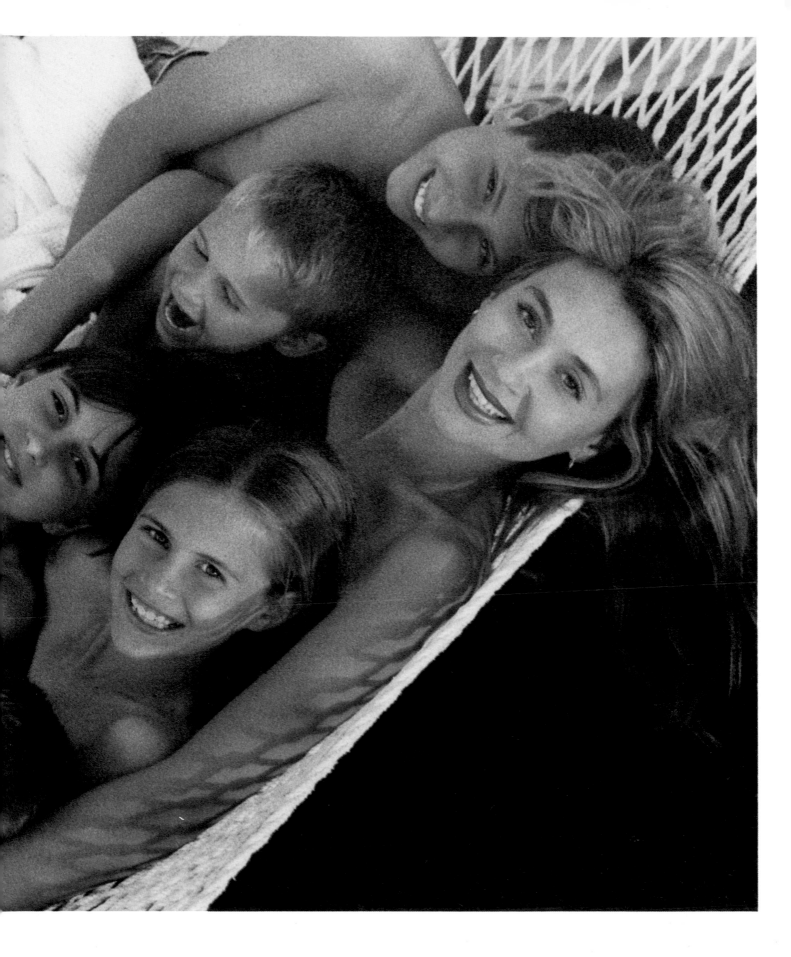

FLEXIBILITY

setting

Although I intended to take a family portrait with our daughter, Skyler, it turned out as a dad and daughter portrait instead. I had a beautiful blue dress and flowers in my hair for the shoot. But unfortunately, Skyler simply wasn't cooperating that day, and I never even ended up in the photos! In fact, this is one of the only shots that turned out from the entire

large silver umbrella

quick reference

shoot. It just goes to show you that you have to remain flexible when working with children. If you do so, you might be rewarded with a nice image like this one.

setting

The portrait was created in my studio with a painted canvas backdrop. The ostrich feather matched the backdrop well, so we added it to the shot for a little texture and added interest.

setting

A silver umbrella was used as the main light for this shot. It was placed high and to the right of the subjects. The image was overexposed one stop to keep the skin tones bright and clear.

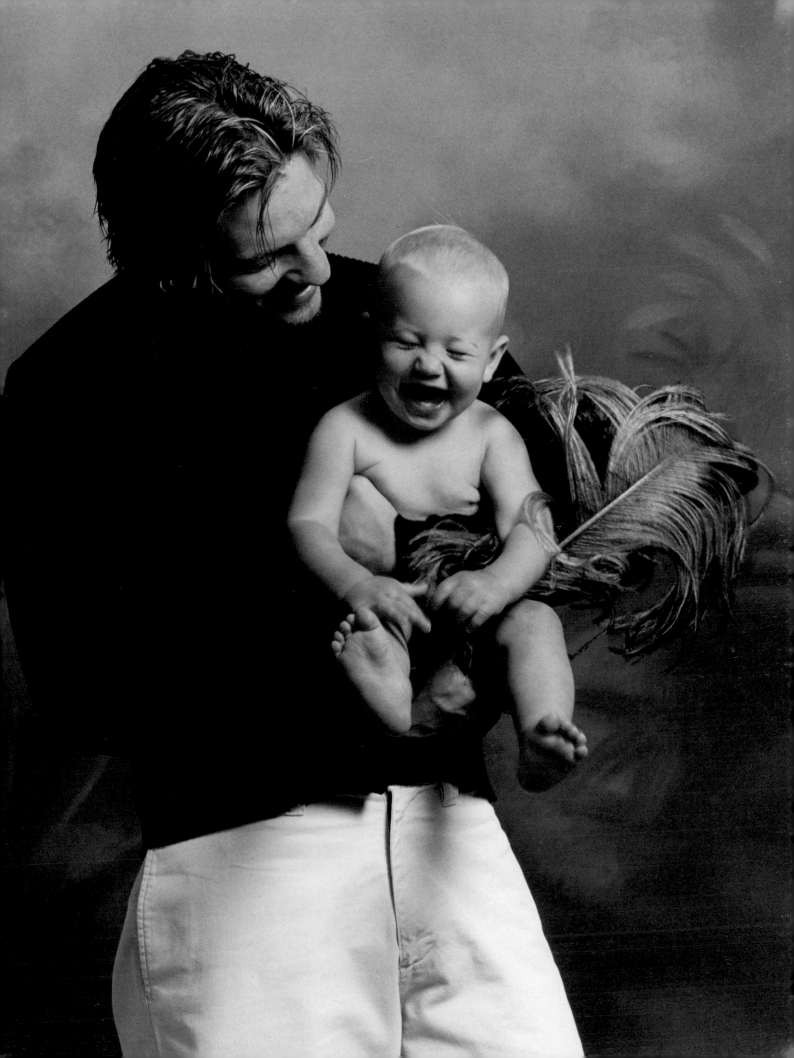

business

getting started

As I always tell people, if you really want to do something, you can do it—just take baby steps along the way. Be prepared for a few surprises along the way, of course.

When I opened my business, I financed it with credit cards and planned to work as the business manager and stylist. Within a short time, however, I found myself having to adjust those plans to become the photographer as well. Over a decade later, the business is thriving, the credit cards have long been paid off, and I love my unanticipated career.

organization

The portrait work shown in this book is the mainstay of my studio's business. We also have sidelines in other areas.

First, we do some wedding photography. I prefer taking my time with an individual or small group to get the best possible shots, so at weddings I normally let my assistant do the formal large group images and stick to shooting casual black & white portraits and candids.

I also do some magazine work, recently a spread for *Family Circle*. I don't pursue this work aggressively, however, since it requires living and/or working in Los Angeles and traveling a lot. I have a child now, so I'm not as willing to do that.

working with clients

The majority of my clients come from my area, but I have had portrait clients fly in from around the country—a very flattering experience! I would

If you really want to do something, you can do it . . .

Well designed direct mail pieces are an excellent way to keep your clients informed about special events, and to let them see your latest work.

back

front

Photography that captures the Soul...

describe my typical client as upscale. Normally, they are seeking quality, rather than quantity in their portraits.

With each session I provide full hair and makeup services. This is a key ingredient in the process for me. There are two

reasons. First, because I can provide this professional service, I can ensure that my clients look their best—probably much

better than they even expect. The result is photographs that make the client feel good. That alone results in improved sales. Secondly, the time spent doing hair and makeup gives me an opportunity to get to know each client better, to develop a rapport and go into the shoot with a better sense of what images will make her the happiest.

I also shoot a lot of film at each session. This means my prices are sometimes a bit higher than others in my market, but clients generally understand this. As I tell them, I shoot a lot of film so that I can ensure they'll get the best possible portrait. I will try out lots of poses and angles and creative ideas with them until we find the ones that create the best, most flattering and attractive portraits.

Your professional image must coordinate with the style of image you produce and the clients you want to attract. Since I specialize in magazine-style portraits, I use graphic, magazine-style brochures and ads.

creativity

Because I strive for variety in my work, my clients also know that their portraits will be unique works of art that are tailored specifically to them.

I work hard to provide this. I am constantly looking through magazines and analyzing the work of other photographers. This keeps me on top of the latest looks and helps me develop new ideas to use with my own

subjects. I also take a day every few months and do a shoot with a test model. I lose a day of shooting with clients, but always take away a few ideas that help keep my work fresh and interesting. Additionally, I have a full wardrobe available along with over 2,000 props and backdrops. Having this variety of tools to work with helps me to customize each session for the individual client.

locations and studio

My business currently operates out of two locations. One is the studio where I do most of my work. This is located a little outside of town near some ranches. The other location is in the more urban beach community about ten minutes away. This location is primarily a gallery.

The city location functions to promote my work. For example, I have a slide show that runs at night in the storefront window of the studio. This creates a little movie for those who walk or drive by it.

Promotions can be developed to build awareness of the full range of styles and services you offer—from black & white, to location portraits, to boudoir images. By developing an evolving selection of styles in your portrait photography, you'll also keep clients (and yourself) more interested in your work.

At both studios, I've worked very hard to create a presentation that suits the quality of my work and the tastes of my clients. You can't expect a client to make an investment in your portraiture if you yourself haven't invested enough in your work to present it in an attractive and pleasing environment. This is especially important in my market, where people tend to be very educated on the latest styles and are interested in what's cool and trendy.

I've consciously tailored my studio with these ideas in mind. For example, when clients come to view their images, they are presented in a room that looks like a theater. There are heavy red theater curtains with tassels, we play their favorite music and we even serve popcorn and champagne!

The room also lets us offer some fun special features. For example, a lot of my clients are

I've consciously tailored my studio with these ideas in mind.

wives who want to surprise their husbands with portraits. For the presentation, they blindfold the husband, bring them into the theater and sit them down. We pop the cork on the champagne, and all of a sudden he sees a gorgeous 30" x 40" image of his wife. This turns the gift into more than a portrait—it's a fun special event.

the future

As I noted in the beginning of this section, I really believe that if you want to do something, you can do it. Just take baby steps along the way and you'll get there.

In the future, my plan is to build my own ranch and to make it the Disneyland of all studios. I love having a wide variety of locations to shoot in, and hope to customize the ranch to include lots of on-site options (maybe even an Italian villa!). My goal is to provide portrait photography that's a real experience for my clients.

As I take my own baby steps toward this goal, I'm just enjoying the opportunity to be creative, and to provide top quality portraits that make my clients feel wonderful.

index

Other Books from
Amherst Media™

Wedding Photographer's Handbook

Robert and Sheila Hurth

A complete step-by-step guide to succeeding in the world of wedding photography. Packed with shooting tips, equipment lists, must-get photo lists, business strategies, and much more! $29.95 list, 8½x11, 176p, index, 100 b&w and color photos, diagrams, order no. 1485.

Infrared Landscape Photography

Todd Damiano

Landscapes shot with infrared can become breathtaking and ghostly images. The author analyzes over fifty of his most compelling photographs to teach you the techniques you need to capture landscapes with infrared. $29.95 list, 8½x11, 120p, 60 b&w photos, index, order no. 1636.

Lighting for People Photography, *2nd Edition*

Stephen Crain

The up-to-date guide to lighting. Includes: set-ups, equipment information, strobe and natural lighting, and much more! Features diagrams, illustrations, and exercises for practicing the techniques discussed in each chapter. $29.95 list, 8½x11, 120p, 80 b&w and color photos, glossary, index, order no. 1296.

Wedding Photography: Creative Techniques for Lighting and Posing, *2nd Edition*

Rick Ferro

Creative techniques for lighting and posing wedding portraits that will set your work apart from the competition. Covers every phase of wedding photography. $29.95 list, 8½x11, 128p, full color photos, index, order no. 1649.

Outdoor and Location Portrait Photography

Jeff Smith

Learn how to work with natural light, select locations, and make clients look their best. Step-by-step discussions and helpful illustrations teach you the techniques you need to shoot outdoor portraits like a pro! $29.95 list, 8½x11, 128p, 60+ b&w and color photos, index, order no. 1632.

Professional Secrets of Advertising Photography

Paul Markow

No-nonsense information for those interested in the business of advertising photography. Includes: how to catch the attention of art directors, make the best bid, and produce the high-quality images your clients demand. $29.95 list, 8½x11, 128p, 80 photos, index, order no. 1638.

Freelance Photographer's Handbook

Cliff & Nancy Hollenbeck

Whether you want to be a freelance photographer or are looking for tips to improve your current freelance business, this volume is packed with ideas for creating and maintaining a successful freelance business. $29.95 list, 8½x11, 107p, 100 b&w and color photos, index, glossary, order no. 1633.

Lighting Techniques for Photographers

Norman Kerr

This book teaches you to predict the effects of light in the final image. It covers the interplay of light qualities, as well as color compensation and manipulation of light and shadow. $29.95 list, 8½x11, 120p, 150+ color and b&w photos, index, order no. 1564.

Infrared Photography Handbook

Laurie White

Covers black and white infrared photography: focus, lenses, film loading, film speed rating, batch testing, paper stocks, and filters. Black & white photos illustrate how IR film reacts. $29.95 list, 8½x11, 104p, 50 b&w photos, charts & diagrams, order no. 1419.

How to Operate a Successful Photo Portrait Studio

John Giolas

Combines photographic techniques with practical business information to create a complete guide book for anyone interested in developing a portrait photography business (or improving an existing business). $29.95 list, 8½x11, 120p, 120 photos, index, order no. 1579.

Fashion Model Photography

Billy Pegram

For the photographer interested in shooting commercial model assignments, or working with models to create portfolios. Includes techniques for dramatic composition, posing, selection of clothing, and more! $29.95 list, 8½x11, 120p, 58 photos, index, order no. 1640.

Computer Photography Handbook

Rob Sheppard

Learn to make the most of your photographs using computer technology! From creating images with digital cameras, to scanning prints and negatives, to manipulating images, you'll learn all the basics of digital imaging. $29.95 list, 8½x11, 128p, 150+ photos, index, order no. 1560.

Black & White Portrait Photography

Helen T. Boursier

Make money with b&w portrait photography. Learn from top b&w shooters! Studio and location techniques, with tips on preparing your subjects, selecting settings and wardrobe, lab techniques, and more! $29.95 list, 8½x11, 128p, 130+ photos, index, order no. 1626

Profitable Portrait Photography

Roger Berg

A step-by-step guide to making money in portrait photography. Combines information on portrait photography with detailed business plans to form a comprehensive manual for starting or improving your business. $29.95 list, 8½x11, 104p, 100 photos, index, order no. 1570

Professional Secrets for Photographing Children

Douglas Allen Box

Covers every aspect of photographing children on location and in the studio. Prepare children and parents for the shoot, select the right clothes capture a child's personality, and shoot story book themes. $29.95 list, 8½x11, 128p, 74 photos, index, order no. 1635.

Handcoloring Photographs Step-by-Step

Sandra Laird & Carey Chambers

Learn to handcolor photographs step-by-step with the new standard in handcoloring reference books. Covers a variety of coloring media and techniques with plenty of colorful photographic examples. $29.95 list, 8½x11, 112p, 100+ color and b&w photos, order no. 1543.

Special Effects Photography Handbook

Elinor Stecker-Orel

Create magic on film with special effects! Little or no additional equipment required, use things you probably have around the house. Step-by-step instructions guide you through each effect. $29.95 list, 8½x11, 112p, 80+ color and b&w photos, index, glossary, order no. 1614.

Family Portrait Photography

Helen Boursier

Learn from professionals how to operate a successful portrait studio. Includes: marketing family portraits, advertising, working with clients, posing, lighting, and selection of equipment. Includes images from a variety of top portrait shooters. $29.95 list, 8½x11, 120p, 123 photos, index, order no. 1629.

The Art of Infrared Photography, *4th Edition*

Joe Paduano

Practical guide to the art of infrared photography. Includes: anticipating effects, color infrared, digital infrared, using filters, focusing, developing, printing, handcoloring, toning, and more! $29.95 list, 8½x11, 112p, 70 photos, order no. 1052

The Art of Portrait Photography

Michael Grecco

Michael Grecco reveals the secrets behind his dramatic portraits which have appeared in magazines such as *Rolling Stone* and *Entertainment Weekly*. Includes: lighting, posing, creative development, and more! $29.95 list, 8½x11, 128p, 60 photos, order no. 1651.

Photographer's Guide to Polaroid Transfer

Christopher Grey

Step-by-step instructions make it easy to master Polaroid transfer and emulsion lift-off techniques and add new dimensions to your photographic imaging. Fully illustrated every step of the way to ensure good results the very first time! $29.95 list, 8½x11, 128p, 50 photos, order no. 1653.

Black & White Landscape Photography

John Collett and David Collett

Master the art of b&w landscape photography. Includes: selecting equipment (cameras, lenses, filters, etc.) for landscape photography, shooting in the field, using the Zone System, and printing your images for professional results. $29.95 list, 8½x11, 128p, 80 b&w photos, order no. 1654.

Wedding Photojournalism

Andy Marcus

Learn the art of creating dramatic unposed wedding portraits. Working through the wedding from start to finish you'll learn where to be, what to look for and how to capture it on film. A hot technique for contemporary wedding albums! $29.95 list, 8½x11, 128p, b&w, over 50 photos, order no. 1656.

Professional Secrets of Wedding Photography

Douglas Allen Box

Over fifty top-quality portraits are individually analyzed to teach you the art of professional wedding portraiture. Lighting diagrams, posing information and technical specs are included for every image. $29.95 list, 8½x11, 128p, order no. 1658.

Photo Retouching with Adobe® Photoshop®

Gwen Lute

Designed for photographers, this manual teaches every phase of the process, from scanning to final output. Learn to restore damaged photos, correct imperfections, create realistic composite images and correct for dazzling color. $29.95 list, 8½x11, 120p, 60+ photos, order no. 1660.

Creative Lighting Techniques for Studio Photographers

Dave Montizambert

Gain complete creative control over your images. Whether you are shooting portraits, cars, tabletop or any other subject, Dave Montizambert teaches you the skills you need to confidently create with light. $29.95 list, 8½x11, 120p, 80+ photos, order no. 1666.

Storytelling Wedding Photography

Barbara Box

Learn how to create outstanding candids and combine them with formal portraits (her husband's specialty) to create a unique wedding album. $29.95 list, 8½x11, 128p, 60 b&w photos, order no. 1667.

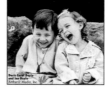

Fine Art Children's Photography

Doris Carol Doyle and Ian Doyle

Learn to create fine art portraits of children in black & white. Included is information on: posing, lighting for studio portraits, shooting on location, clothing selection, working with kids and parents, and much more! $29.95 list, 8½x11, 128p, 60 photos, order no. 1668.

Infrared Portrait Photography

Richard Beitzel

Discover the unique beauty of infrared portraits, and learn to create them yourself. Included is information on: shooting with infrared, selecting subjects and settings, filtration, lighting, and much more! $29.95 list, 8½x11, 128p, 60 b&w photos, order no. 1669.

Black & White Photography for 35mm

Richard Mizdal

A guide to shooting and darkroom techniques. Perfect for beginning/intermediate photographers who want to improve their skills. Features illustrations and exercises to make every concept easy to follow. $29.95 list, 8½x11, 128p, 100+ b&w photos, order no. 1670.

Marketing and Selling Black & White Portrait Photography

Helen T. Boursier

A complete manual for adding b&w portraits to the products you offer clients (or offering exclusively b&w photography). Learn how to attract clients and deliver the portraits that will keep them coming back. $29.95 list, 8½x11, 128p, 50+ photos, order no. 1677.

Innovative Techniques for Wedding Photography

David Neil Arndt

Spice up your wedding photography (and attract new clients) with dozens of creative techniques from top-notch professional wedding photographers! $29.95 list, 8½x11, 120p, 60 photos, order no. 1684.

Infrared Wedding Photography

Patrick Rice, Barbara Rice & Travis HIll

Step-by-step techniques for adding the dreamy look of black & white infrared to your wedding portraiture. Capture the fantasy of the wedding with unique ethereal portraits your clients will love! $29.95 list, 8½x11, 128p, 60 images, order no. 1681.

Photographing Children in Black & White

Helen T. Boursier

Learn the techniques professionals use to capture classic portraits of children (of all ages) in black & white. Discover posing, shooting, lighting and marketing techniques for black & white portraiture in the studio or on location. $29.95 list, 8½x11, 128p, 100 photos, order no. 1676.

Dramatic Black & White Photography:
Shooting and Darkroom Techniques

J.D. Hayward

Create dramatic fine-art images and portraits with the master b&w techniques in this book. From outstanding lighting techniques to top-notch, creative darkroom work, this book takes b&w to the next level! $29.95 list, 8½x11, 128p, order no. 1687.

Posing and Lighting Techniques for Studio Photographers

J.J. Allen

Master the skills you need to create beautiful lighting for portraits of any subject. Posing techniques for flattering, classic images help turn every portrait into a work of art. $29.95 list, 8½x11, 120p, 125 fullcolor photos, order no. 1697.

Studio Portrait Photography in Black & White

David Derex

From concept to presentation, you'll learn how to select clothes, create beautiful lighting, prop and pose top-quality black & white portraits in the studio. $29.95 list, 8½x11, 128p, 70 photos, order no. 1689.

Watercolor Portrait Photography: The Art of Manipulating Polaroid SX-70 Images

Helen T. Boursier

Create one-of-a-kind images with this surprisingly easy artistic technique. $29.95 list, 8½x11, 120p, 200+ color photos, order no. 1698.

Corrective Lighting and Posing Techniques for Portrait Photographers

Jeff Smith

Learn to make every client look his or her best by using lighting and posing to conceal real or imagined flaws – from baldness, to acne, to figure flaws. $29.95 list, 8½x11, 120p, full color, 150 photos, order no. 1711.

Master Posing Guide for Portrait Photographers

J. D. Wacker

Learn the techniques you need to pose single portrait subjects, couples and groups for studio or location portraits. Includes techniques for photographing weddings, teams, children, special events and much more. $29.95 list, 8½x11, 128p, 80 photos, order no. 1722.

Make-Up Techniques for Photography

Cliff Hollenbeck

Step-by-step text paired with photographic illustrations teach you the art of photographic make-up. Learn to make every portrait subject look his or her best with great styling techniques for black & white or color photography. $29.95 list, 8½x11, 120p, 80 full color photos, order no. 1704.

Professional Marketing & Selling Techniques for Wedding Photographers

Jeff Hawkins and Kathleen Hawkins

Learn the business of successful wedding photography. Includes consultations, direct mail, print advertising, internet marketing and much more. $29.95 list, 8½x11, 128p, 80 photos, order no. 1712.

Professional Secrets of Natural Light Portrait Photography

Douglas Allen Box

Learn to utilize natural light to create inexpensive and hassel-free portraiture. Beautifully illustrated with detailed instructions on equipment, setting selection and posing. $29.95 list, 8½x11, 128p, 80 full color photos, order no. 1706.

More Photo Books Are Available

Contact us for a FREE catalog:

AMHERST MEDIA
PO BOX 586
AMHERST, NY 14226 USA

www.AmherstMedia.com

Portrait Photographer's Handbook

Bill Hurter

Bill Hurter has compiled a step-by-step guide to portraiture that easily leads the reader through all phases of portrait photography. This book will be an asset to experienced photographers and beginners alike. $29.95 list, 8½x11, 128p, full color, 60 photos, order no. 1708.

Ordering & Sales Information:

INDIVIDUALS: If possible, purchase books from an Amherst Media retailer. Write to us for the dealer nearest you. To order direct, send a check or money order with a note listing the books you want and your shipping address. Freight charges for first book are $4.00 (delivery to US), $7.00 (delivery to Canada/Mexico) and $9.00 (all others). Add $1.00 for each additional book. Visa and MasterCard accepted. New York state residents add 8% sales tax.

DEALERS, DISTRIBUTORS & COLLEGES: Write, call or fax to place orders. For price information, contact Amherst Media or an Amherst Media sales representative. Net 30 days.

1(800)622-3278 or (716)874-4450
FAX: (716)874-4508

Traditional Photographic Effects with Adobe Photoshop

Michelle Perkins and Paul Grant

Use Photoshop to enhance your photos with handcoloring, vignettes, soft focus and much more. Every technique contains step-by-step instructions for easy learning. $29.95 list, 8½x11, 128p, 150 photos, order no. 1721.

All prices, publication dates, and specifications are subject to change without notice.
Prices are in U.S. dollars. Payment in U.S. funds only.